THE COMPLETE STEP-BY-STEP DRAWING COURSE

THE COMPLETE STEP-BY-STEP DRAWIG COURSE

CHANCELLOR

→ PRESS →

Executive Manager Compiling Editor Art Editor Designer Kelly Flynn Freda Parker Colin Robson Ruth Levy Suzie Lanni

Designer
Design Assistant
Editorial Assistant
Production

Elizabeth Hubbard Peter Phillips

Special thanks to the following for the use of their illustrations:

Simon Birkett, 25, Alison Chapman, 71, 83, Patrick Collins, 7, 20, 25, Mark Draisey, 24, Julia Gash, 1, 16, 17, 21 71, 82, 83, Carol Hellman, 32, Roxanne Jackson, 3, 64, 95, Robert Lee, 21, Mary Marland, 13, 107, Beverley Poole, 16, 28, Julia Powell, 13, Polly Raynes, 32, 33, 37, 73, Nick Read, 12, Steve Smith, 29, Kate Thomas, 28, Helen Ward, 32, 84.

Previously published under the title *The Complete Book of Drawing* by the Artists House Division of Mitchell Beazley International Ltd, part of Reed International Books.

This edition published in 1992 by Chancellor Press, Michelin House, 81 Fulham Road, London SW3 6RB

© Reed International Books Ltd 1982, 1983, 1986

All rights reserved. No part of this work may be reproduced or utilized in any form by any means, electronic or mechanical, including photocopying, recording or by any information storage and retrieval system, without the prior written permission of the publisher.

ISBN 1 85152 229 8

Printed in Malaysia

CONTENTS

HOW TO USE THIS BOOK

Whatever kind of drawing you want to do, this book should prove extremely useful. It can be followed from start to finish as a complete drawing course, introducing you to the full range of techniques and media, and it can be referred to again and again when you need solutions to specific problems.

This book is divided into four sections covering materials, techniques, drawing aids

and useful reference. A glossary explains the technical terms. Some of the illustrations are included as step-by-step examples of the techniques, others are diagrams.

Use this book to increase the range of subjects you can handle confidently. It should also encourage you to try new materials. But use it also as a means of developing your own personal style.

MATERIALS-		Life drawing	55	Architectural details	90
Introduction	6	Foreshortening	58	Composing from sketches	92
Paper	8	Composition	60		
Charcoal	10	Movement	61	——DRAWING AIDS	
Pencils	14	Groups and portraits	62	Introduction	94
Crayons	18	Drawing children	64		96
Pastels	22	Animal structure	66	Enlarging reducing guides	
Pens and inks	26	Animals	68	Tracing	98
Watercolour	30			Masks	100
The work area	34	LANDSCAPE		Monotype print making	102
TECHNIQUES		Working outdoors	70	Reproducing drawings	104
		Landscape drawing	72		
Drawing with a grid	38	Composing the picture	74	REFERENCE-	
Planes and simple tones	40	Sky and water	76	Introduction	106
		Trees	78	Making drawing tools	108
Sight size scale and measurin	-	Seascape	80	Paper	110
Defining form	44	Sketchbook drawings	82	·	
Drawing a still life	46	Perspective	86	Mounting and framing	114
Flowers	48			Storage	116
THE FIGURE		BUILDINGS		Glossary	118
Anatomy and structure	50	Drawing buildings	88	Index	119

MATERIALS

Choosing materials that are compatible with the subject you are drawing will widen the scope of your expression and should be explored.

A selection of drawing tools and paper, with suggestions on how they may be used, has been given on the following pages, but keep up to date by visiting artists' suppliers to stay in touch with what is new on the market and by going to exhibitions and looking at what other people are using. Experiment with everything you see, and remember that there are no rules in your choice of material. To convey the character of the same subject one person may choose to explore the textural qualities on a piece of tinted rough paper using chalk, another may prefer pen and ink on smooth white paper. Have a large assortment of materials to hand and use them all. If you cannot get along with one, move on and try another.

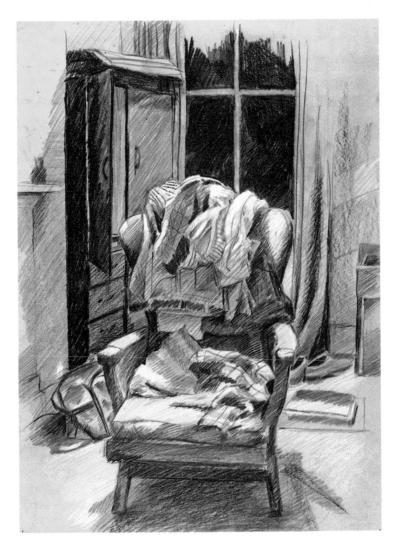

Carté crayon and chalk look particularly well on tinted paper, which gives a subtle extra dimension when incorporated into a composition.

PAPER

The character of a paper can totally change the effect of a drawing so it is very important to be aware of the wide variety available. Certain papers are generally recommended for certain materials and this is useful as a guide but should not necessarily be adhered to; the most interesting results can come from using what might be regarded as a totally unsuitable paper.

Before buying paper consider exactly what you want from it.

The information on these pages will help you to decide.

Paper is made by three different methods. Handmade is the best quality and most expensive; it is hard-wearing and long-lasting and both sides of the sheet can be used. Mould made is a good quality machine-made paper that imitates handmade but has a right and wrong side. Machine made is produced by a continuous web process; it is the least expensive type of paper and does not have the character of handmade.

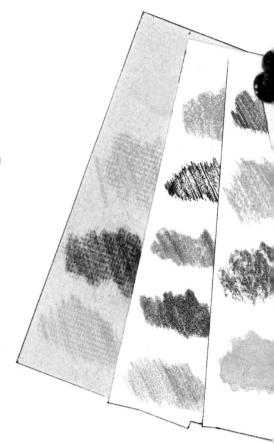

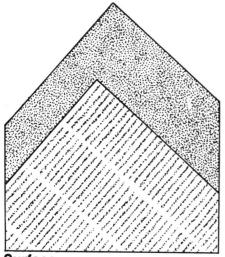

Surface

Hot pressed (HP): pressed to give a smooth, hard surface. Not pressed: ie not hot pressed; lightly pressed to give a slightly textured surface. A useful all-purpose paper. Rough: dried naturally without being pressed to give a rough, toothed surface. 1 Wove: paper with a continuous, even texture, produced by the woven wire mesh of the mould in which the paper is formed. 2 Laid: paper that shows the impression of the chain lines of the mould at regular intervals across the sheet (Ingres is one such paper).

Right and wrong side

Handmade papers have the same surface on both sides. To distinguish the wrong side of a machine — or mould-made paper look for the impression of the fine mesh of the machine web. Do not use the watermark as a guide.

Quality

The quality of paper determines its longevity. The best quality is made from cotton rag. It is the acidity (measured on a pH scale – 7.0 is neutral) that affects the quality; an acidic paper will fade, discolour and disintegrate. See p116 for test for paper fading.

Grain or direction

Handmade paper has no grain. The grain of a machine-made paper follows the direction of the web, the way the fibres were pulled, making it easier to tear and fold in that direction.

Quantity and form

It is cheaper to buy paper in bulk, by the quire (25 sheets) or by the ream (500 sheets). Machine-made paper is sometimes available in a roll. Paper can be bought mounted on board or in blocks (a pad glued at the edges), and also of course, in sketchbooks, either case or spiral bound.

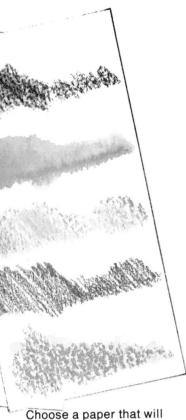

Weights and measures

Paper sizes and weights are going over to metrication but some papers are still measured in Imperial. Weight is measured in pounds per ream (eg 72 pounds – light, 300 pounds – heavy) or in grams per square metre (gsm or gm², eg 100gsm – light, 640gsm – heavy).

Metric				
A0				
841 ×	1189mm			
A1				
594 ×	841mm			
A2				
420 ×	594mm			
A3				
297 ×	420mm			
A4				
210 ×	297mm			
A E				

148 × 210mm

Imperial
Antiquarian 53×31 in (1346 \times 787mm)
Double Elephant $40 \times 26\frac{1}{4}$ in (1016 \times 679mm)
Imperial $30\frac{1}{2} \times 22\frac{1}{2}$ in (775 \times 572mm)
Double Crown 30×20 in (762 \times 508mm)

Royal 24 \times 19in (610 \times 483mm) Medium 22 \times 17½in (559 \times 444mm)

Choosing a paper

Compare the marks made by various media on a smooth Bristol Board and on rough watercolour paper. Judge their suitability for yourself.

	Pencil
	Charcoal
Millight Millight States of the Control of the Cont	Pen and ink
	Soft pastel
	Watercolour wash

enhance the quality of the medium and add to the mood of your drawing. The brilliance of a white paper varies greatly, and there is a large range of coloured papers to choose from. How absorbent do you want your paper to be? The amount of glue sizing determines this and varies from paper to paper. Do you want a rough or smooth paper?

Smooth paper Hot pressed, smooth paper is generally recommended for detailed work in line or tone, particularly suitable for pencil and pen and ink and also for crayon.

Textured paper Not or rough papers give an interesting texture, and provide a tooth for charcoal and pastel to grip.

Some good quality papers generally available in the UK and US are: R.W.S., a cotton handmade watercolour paper (HP, Not and Rough); Saunders, cotton rag mould-made watercolour paper (HP, Not and Rough); Bockingford, acid-free wood pulp machine-made artists' paper (Not); Aquarelle Arches, cotton mould-made paper (HP, Not Rough); Fabriano, cotton hand- and

mould-made paper (HP, Not and Rough), Strathmore produce good artists' papers in the US. There are many cartridge papers of various qualities and weights; Bristol Board, detail and tracing paper all have a smooth finish; Ingres paper (made by

Fabriano, Canson and Mi Teintes) is a tinted, laid paper which sometimes has a fleck, and is suitable for charcoal and pastel.

CHARCOAL

Charcoal has great versatility, expressed in the widest range of marks, from light to very black; from simple line to gradated tone. Textured, tinted and ordinary cartridge paper – even brown wrapping paper – are suitable for charcoal drawings; shiny surfaces are not. The medium has great freedom and energy, although you may find it messy at first and need practice to gauge the brittleness of willow charcoal.

Because of its dusty quality, you must draw with your hand raised off the paper. To keep the lines sharp, spray on a fixative as areas of the drawing are completed.

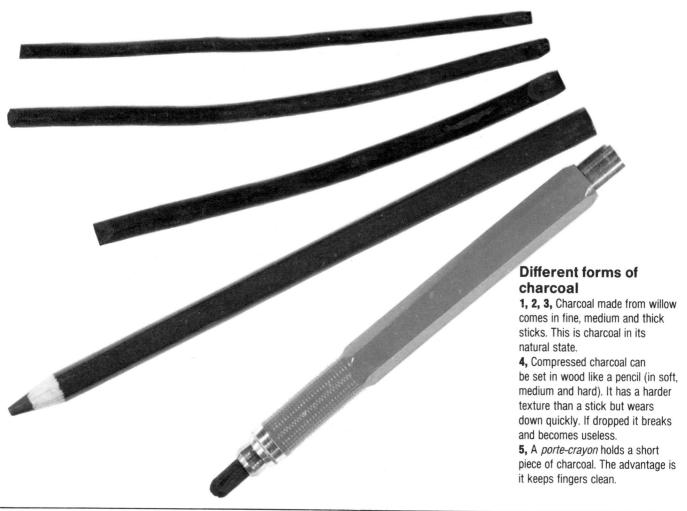

Highlights

A kneadable putty eraser can be used to pick out the highlights in toned areas. Tear off a small piece and shape to a point. Dab on and pick off the charcoal gradually, turning to a clean side of the eraser each time. White chalk can be used for more dramatic highlights when drawn on tinted paper.

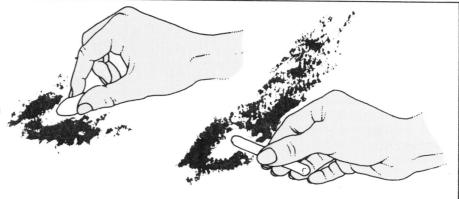

Drawing with charcoal

Charcoal used in line has a speed and boldness, a spontaneity which is more appropriate to large, free drawings than to precision work.

When laid flat on textured paper, a short piece of willow charcoal is ideal for drawing contrasting areas.

Fingers or a stump will smudge and soften lines. Powdered charcoal from the chemist, or crumbled short pieces, can be used to gain effects.

To dust off charcoal a fine, soft cloth can be gently flicked at the mark. A putty eraser will then rub out most lines.

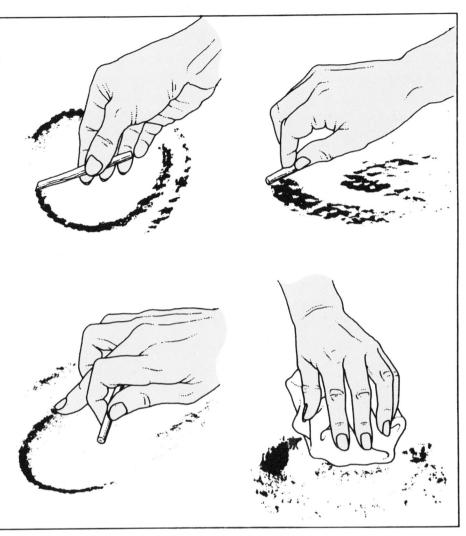

Sharpening willow charcoal

1 By turning the charcoal frequently when drawing, it will remain pointed. It can be given an edge with a knife, or simply by breaking it.

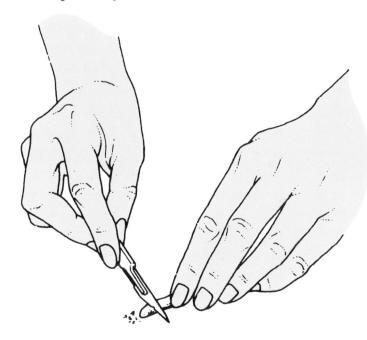

2 The best way to achieve a precise point is to use fine emery paper or to rub it to a chisel shape on a scrap of coarsely textured paper.

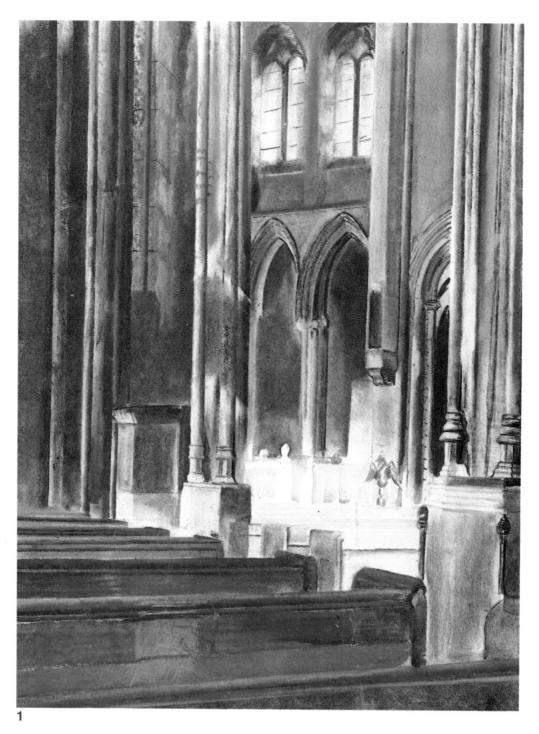

1 A very strong, solid architectural drawing in charcoal and watercolour convincingly conveys light falling on the central aisle of

central aisle of the church. The careful selection of verticals maximizes the impression of the perpendicular style of the building.

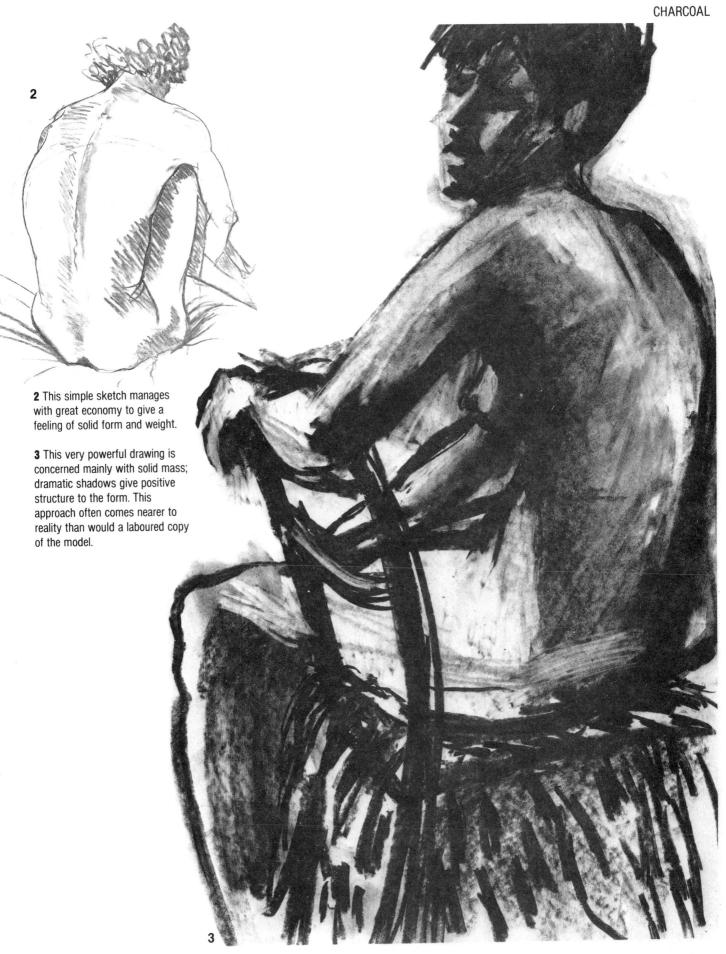

PENCILS

A lead pencil is a misleading name as the 'lead' is actually graphite, a form of carbon. In fact, to add to the confusion, the term 'pencil' was used in the past to describe a finely pointed brush. It was Nicolas-Jacques Conté who patented the process of varying the degree of hardness in graphite towards the end of the eighteenth century, thereby boosting its popularity as a medium for permanent drawing.

The great attraction of the pencil, familiar though it is, lies in its immediacy, its versatility and its sensitivity. The ease with which it can be erased should not be ignored either. Although made in grades of softness and hardness, the pressure on the pencil and the texture or grain of the paper also lend variety. The pencil is equally capable of producing a quick study or of creating a finely detailed drawing.

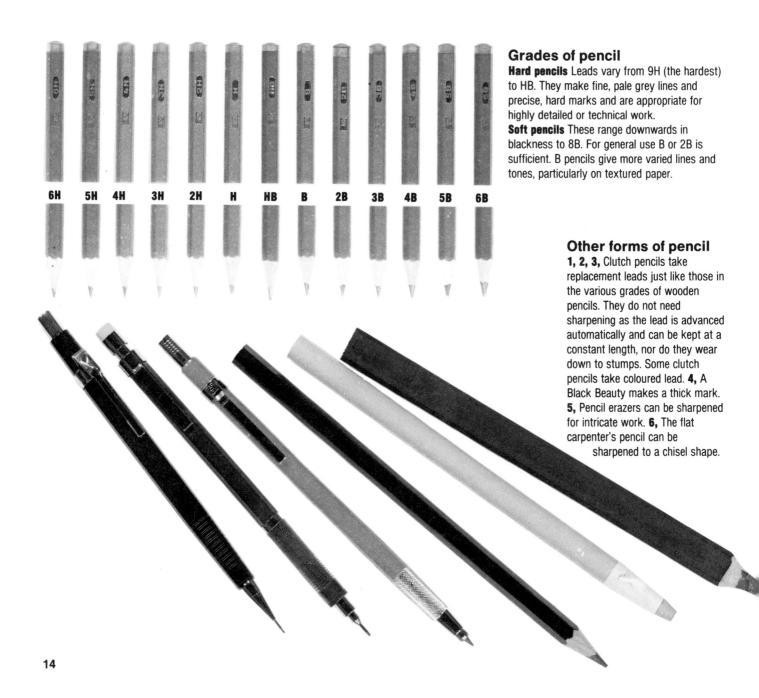

How to hold the pencil

The pencil in drawing is a linear tool and by its response to pressure will make a variety of lines. To some people it is a writing instrument and to control it sufficiently means holding the pencil close to the lead. Writing is concerned with making small marks of similar size, essentially a finger/wrist movement. Resting the hand on the paper in the conventional manner is the correct way for detailed drawing. This method may be extended if you want to achieve a broader range of marks, in which case hold the pencil nearer the blunt end, leaving you free to draw from the elbow or even the shoulder if you want to make a more sweeping line. Grasp the pencil comfortably with the hand relaxed. The fingers should support rather than grip it.

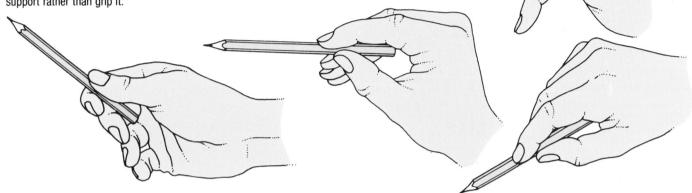

Hard pencil is good for precision work if sharpened to a fine point, but once a mark has been made it can be difficult to erase. It will give a limited range of fairly light tones, which can take on a smooth, almost glassy look if handled subtly.

Making tones with pencil

Lightly shade all the areas that you want to be toned with a 2H pencil. Increase the pressure of shading with the same pencil in the areas that you want to be darker. Lightly rub with the finger to soften tonal gradation into the paper.

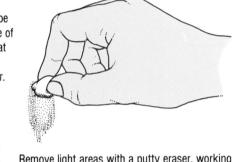

Remove light areas with a putty eraser, working slowly. The surface is now smooth and more responsive to increased toning with a B or 2B pencil. For a very dark area use a 4B. Dark tones can then be polished with an H pencil.

Sharpening pencils

B pencils wear quickly. Pencil sharpeners eat up too much wood before coming to a point, and give too short a lead. If a knife is used, wood can

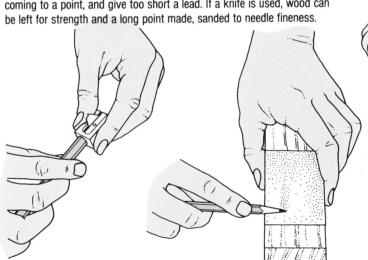

Soft pencil gives tonal variation depending on the pressure or the degree of tonal build-up. Vary the line by sharpening the pencil for more precision; leave it blunt for a broader line.

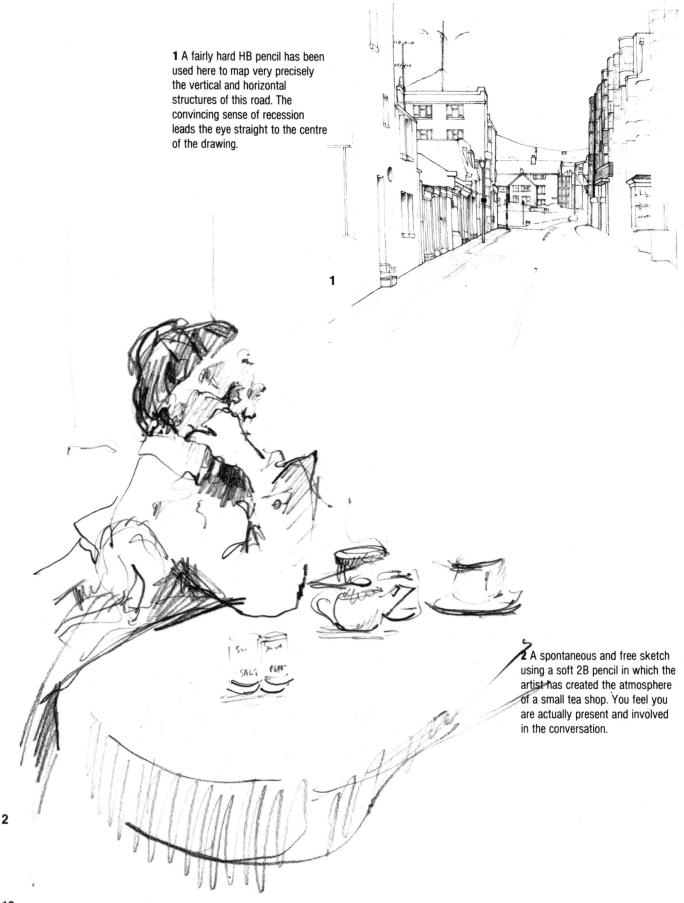

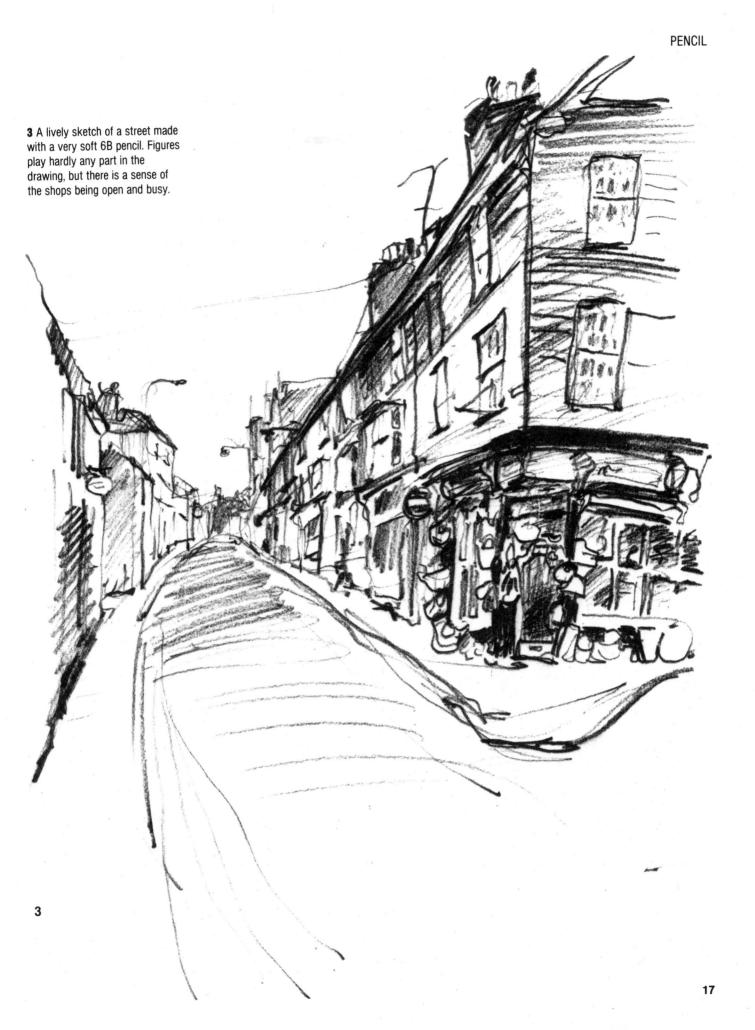

CRAYONS

Everyone is familiar with the crayon boxes and colouring books of childhood yet may have little opportunity in adulthood to reacquaint themselves with the delights of making coloured drawings. There is an extensive range of pencils, crayons and chalks on the market, loosely grouped under the heading of crayons, in a wide variety of prices. Their use is by no means restricted to children, as many artists find great satisfaction in being able to enjoy the essential simplicity of a pencil but with the added fillip of working in colour.

The permanence of crayon drawing is not their strong point. They are fragile and impossible to clean, their appeal is in their spontaneity not their durability.

Using crayons

Some crayons such as conté pencils and coloured pencils can be sharpened to a point but the distinguishing characteristic of most crayons is a soft, sensuous line that can be either strongly defined or gently broken, and in part is dependent on the surface on which it is drawn. Whether used on their own, with a watercolour wash, or in conjunction with other media, crayons seem to have an irresistible charm.

Conté crayons

Conté crayons (above) do not break or smudge easily as they are slightly greasy and more finely textured than charcoal. They are limited to sepia (brown), white, three degrees of black, and sanguine (terracotta). Pencils (left) and sticks respond sensitively to any type of surface.

Water colour pencil

Derwent colour block

Chinagraph

Coloured pencil
Conté pencil

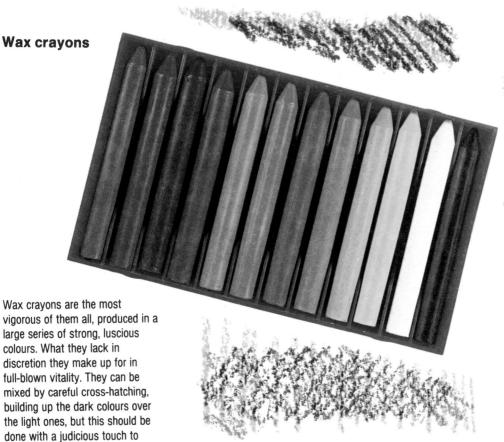

Water-soluble crayons

Some crayons are water soluble, which means that a straightforward line can be transformed into a wash of colour by the application of a sable brushload of plain water, leaving behind a faint shadow of the crayon outline.

Using conté crayons

make a line just as dark as a

charcoal line.

Use the side, or the edge of the point for tonal drawing. It will accentuate the grain of the paper: the light tones can be heightened with white conté.

Crayons combined with other media

Wax crayons and wash

keep the colours fresh.

Draw in highlights with white wax crayon (a candle will do); lay watercolour over it. This rolls off the wax, leaving the white paper.

Wax crayons and coloured pencils

Draw with the pencils over wax crayon marks. The wax will resist the pencil, making an interrupted or random pattern.

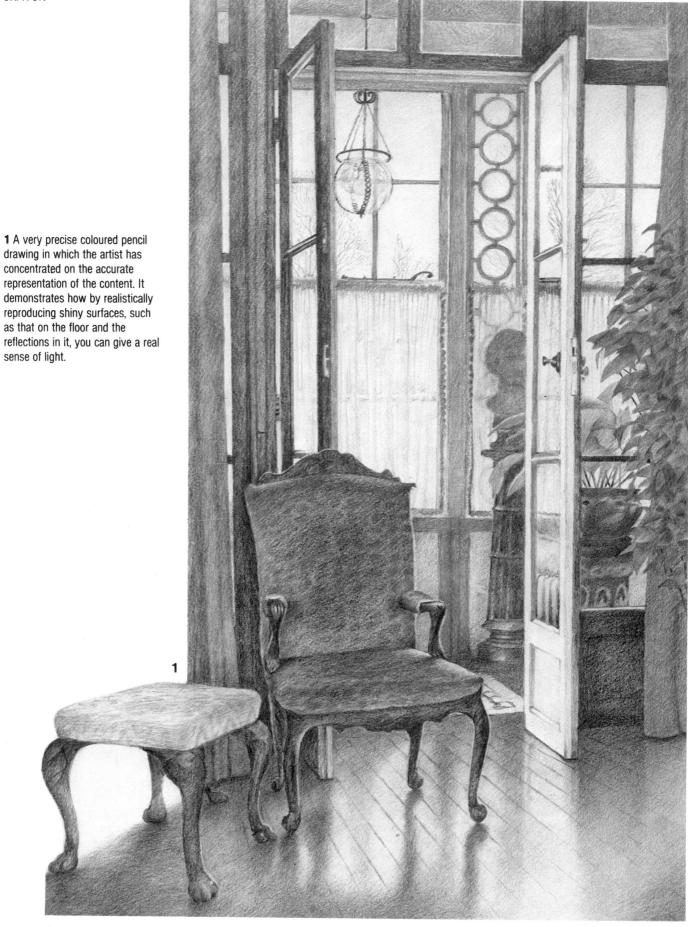

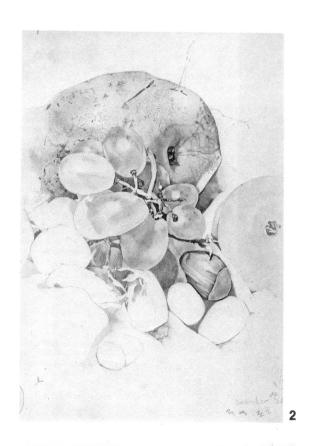

2 This combination of coloured pencil and watercolour has made a very sensitive drawing, giving a wonderful impression of almost transparent grapes against the more solid form of the pear. An interesting effect has been achieved by concentrating the colour in certain areas of the drawing, leaving others quite unfinished.

3 This very vigorous drawing in wax crayon is full of spirit. Very little detail is drawn in but the artist has managed to give a superb impression of Victorian architecture. Featuring the red paintwork on the building creates a more colourful drawing.

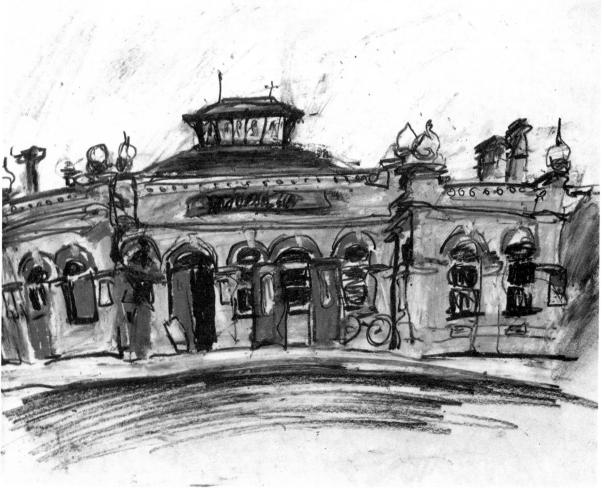

3

PASTELS

There are three types of pastel: the soft pastel stick, the oil pastel and the pencil. Unlike oils and watercolours, soft pastels, the most popular form, have kept their true colour values and freshness over the centuries as they contain no additives and are not varnished. They are made from pigment, chalk and gum in more than 600 tints. Soft pastels cannot be mixed as you go along, so you will need about 40 as a basic collection. When working outside, carry pastels in a box and take tissue paper, cardboard and tape to protect the finished work.

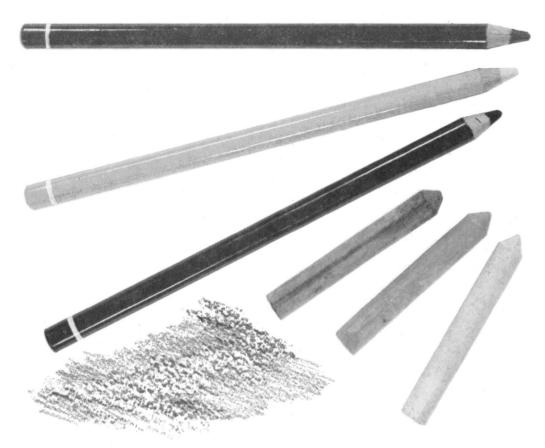

Soft pastels First, block out the composition over a pencil outline in broad strokes with the pastel-stick on its side. This gives the basic colour design of the whole composition over which details can then be built up.

Use the point of the pastel to make cross-hatchings, and so refine the impression. For maximum effect, put warm colours over cool ones, or vice versa. Here, in the foreground – cold blue sets off warm red.

Pastel pencils

These are not as crumbly as soft pastels; they have a narrow colour range and make a precise mark.

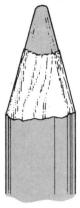

Pastel papers

The best surface for pastels is paper. It is also considered the most durable. The paper should have a 'tooth' (a textured surface to which the particles of chalk cling) and soft colour: Bockingford, Saunders, Ingres and coloured wrapping papers are all suitable. although the striations of 'laid' paper may be distracting. White paper is a poor substitute for the deliciously tinted grey, fawn or smoky blue papers which can be incorporated into the composition and left exposed in places to add an extra dimension. The grain can be used to imply texture.

Oil pastels

Although oil pastels can be confused with soft pastels, they are not interchageable and should not be mixed together in a drawing. The colours are limited and rather bright. Oil pastels are considered a painting medium; they can be used on canvas or board as well as paper, and are sometimes mixed with turpentine to make a wash which is applied with a brush.

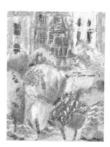

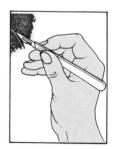

Oil pastels. Sketch in the composition lightly. Overlay other colours, blending them in, or, with a sharp blade, scrape at the pastels in linear strokes, revealing the paper or the colour beneath, depending on pressure applied.

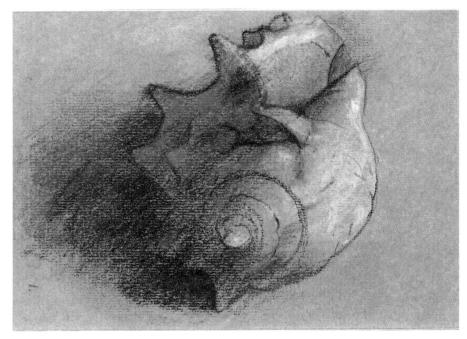

The degree of pressure on the pastel helps to determine different effects. Cross-hatching, or alternating thick and thin strokes made with the end of the pastel and a broken edge, are ways of achieving tone and shading.

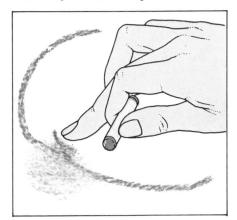

When pastels are built up, making thick marks, the effect has much in common with oil painting. Fragonard used his fingers to imitate this richness. A finger can also soften edges.

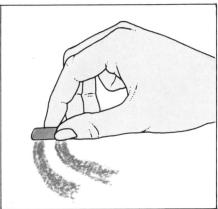

Group all your colours and tones in families on corrugated paper so that they are easily to hand. For an area of colour or texture use a short piece of chalk on its side. Keep the wrapper for future identification.

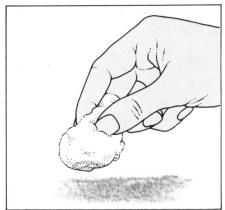

Initial strokes should be firm but light to avoid clogging the grain of the paper. If making alterations, dust off first with cotton wool before adjusting. This prevents a sticky build-up.

Soft pastel

This versatile medium can be used to suggest line, tone and colour. It can be used either by building up a series of cross-hatching (see facing page) or by blending. Edges can be defined with the point of the pastel or with a pastel pencil. In the drawing on the left, the grey-tinted paper sets the mid-tone, black was used for the dark tones merging into shadow and to define the edges in light areas; white gives highlights and red ochre adds a tint.

Rubbing out

This is not easy. A putty eraser will spoil the glow of the paper, which is important if you intend to leave some of the paper exposed in places. A hog brush, as used for painting in oils, can be more effective. The bristles remove most of the chalk from the grain of the paper without destroying the tooth.

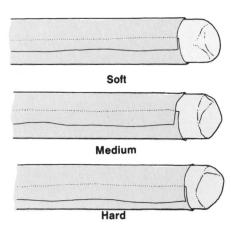

Grades of pastel

Pastels are graded from 0 to 8, from lightest to darkest. Very light tones are softer and contain more chalk; the darker colours are made up of a greater percentage of pigment and are generally harder in consistency. Some pigments are harder than others despite grading (yellow ochre 4 is not as fragile as cobalt blue 4).

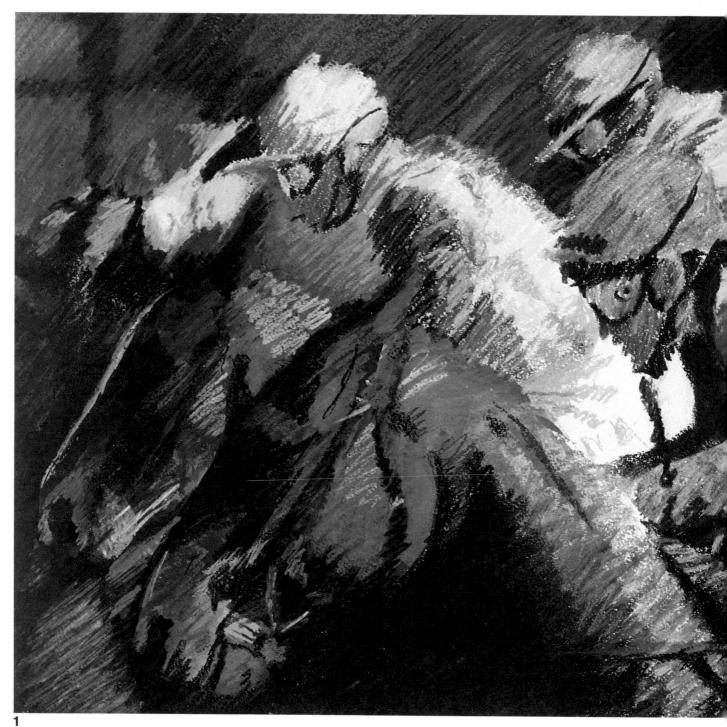

1 The pastel colour has been applied on a tinted grey paper with diagonal strokes creating a blurred effect which adds to the sense of the speed of the racing horses.

2 An impressionistic approach using pastels on a sand coloured stock gives a feel of heat to this landscape. The buildings are drawn in with a little more detail than the vegetation which has been treated in a loose, almost abstract way.

A very tight drawing which illustrates a very different application of the medium. Pastels have been used in a very solid way making the main focal point of the picture the contrast between light and dark.

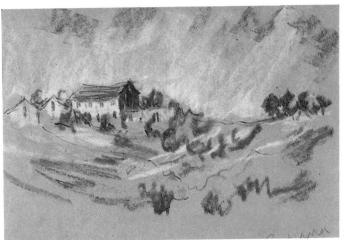

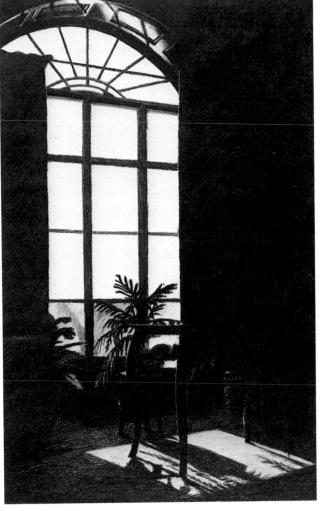

PENS & INKS

Any pointed instrument can be dipped into ink to make a mark – a sharpened twig, a match stick, the end of a brush, a piece of trimmed bamboo, or a dried cow parsley stalk. Ink is a line medium so that various techniques such as hatching, stippling and combinations of marks must be employed to convey tone, or a wash of diluted ink or watercolour may be applied with a brush. Other effects can be achieved by laying a wash over a wax resist, blowing blots, and working with the fingers to give textures. The heavier the paper, the less chance of spoiling it if there has been much erasing, because when a wash is to be part of the drawing, it will not roll on smoothly if the surface has been roughened.

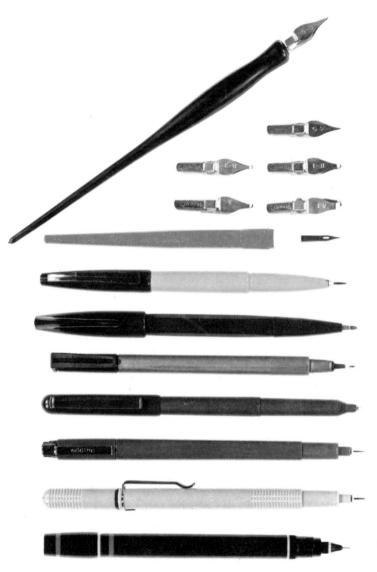

Ball points and fibre tips 3–8 are the antithesis of precise technical

pens. They are made in several colours and make lively marks difficult to control.

9 Technical pens draw consistently even lines and move in any direction.

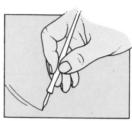

A dip pen loaded with ink can be used quite freely. Do not be afraid to emphasize or even correct lines with firm strokes, and build up dark areas with cross-hatching.

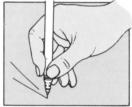

Technical pens should be used on hard paper. They are good for slow, controlled drawing (as the diagram above) but can also build up freer drawings (right). Hold the pen upright.

Fibre-tip pen

This relatively insensitive medium produces a consistent line that can be difficult to vary (particularly in small-scale drawings). Lines can be softened if moistened with a slightly damp brush. Transparent tones can be achieved with the use of light hatching.

Various pen marks

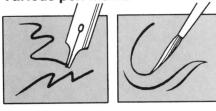

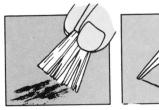

Those who have little experience with a pen will need to practise on some smooth paper to get the ink to flow evenly from the nib. 1 A dip pen; 2 a fine sable brush, producing an expressive line; 3 dry brush technique, the bristles splayed out with the fingers; 4 the quill's crisp line; 5 a stylo-tip pen, giving a controlled line or stippling; 6 A fibre tip, which results in an energetic line; 7 the thin, scratchy line of a mapping pen; 8 a wash applied with a large sable.

Ball-point

Ball-point can produce some surprisingly effective results, although drawings will tend to fade in time. The weight of the line can be easily controlled to build up from light, spidery lines to

controlled to darker tonal areas. It flows well and can be used to explore volume in a series of repetitive contour

lines.

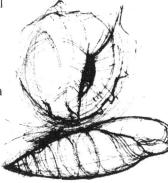

Combining pen and ink with wash

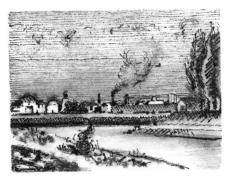

Pen work over a composition of dry colour washes gives a crisp line, which contrasts to good effect with the more atmospheric washes.

For a different effect, dampen the surface of the colour wash, then add pen work. Or, lay a wash on pen, using non-waterproof ink.

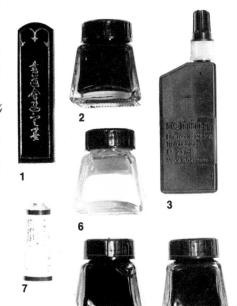

Inks

1 Chinese inkstick: long-lasting; creates any density of black. Dries matt; is excellent on all surfaces. 2 Indian ink leaves a strong glossy line. Dilute with distilled water. 3 Filler bottles for stylo-tip pens. 4 Coloured inks are water-resistant but not colour-fast (may take 15 years to fade away). 5 Non-waterproof inks can be diluted with tap water and are produced in limited colours. Drawing on wet paper will give soft lines. 6 Chinese white is for tinted papers. 7 Watercolour for laying washes.

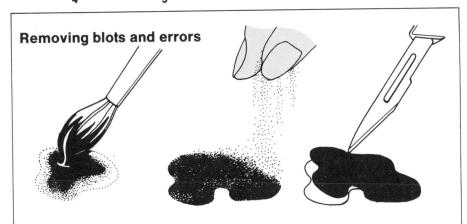

Blotting paper or a small sable absorbs spilt ink. Dry ink is scratched off hard surfaces with a blade.

Sand or salt will dry up blots and can then be shaken off. Erase remaining stain with an India eraser. With fresh paper underneath, cut around a mistake with a knife. Tape the clean piece on from the back.

1 In this dip pen and ink drawing of a camel the artist has used a very loose line to great effect. Showing the camel's legs in various active positions creates a genuine sense of speed and movement.

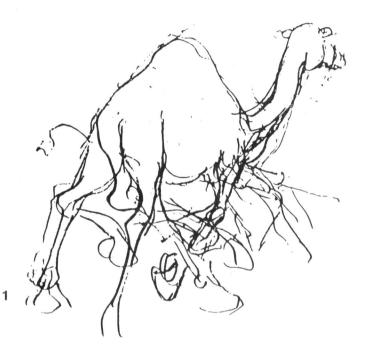

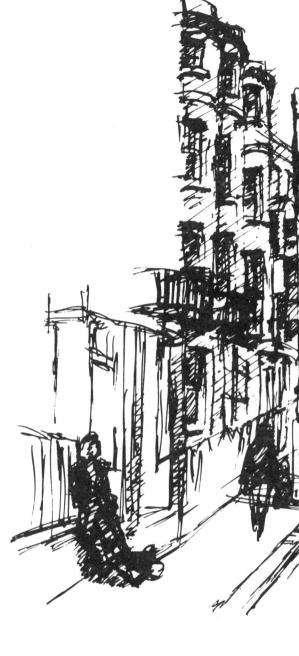

2 Cross-hatch techniques enable the artist to suggest solids with single pen strokes. In this Rapidograph still life the range of tones possible with cross-hatching has been utilized to create the forms of the objects.

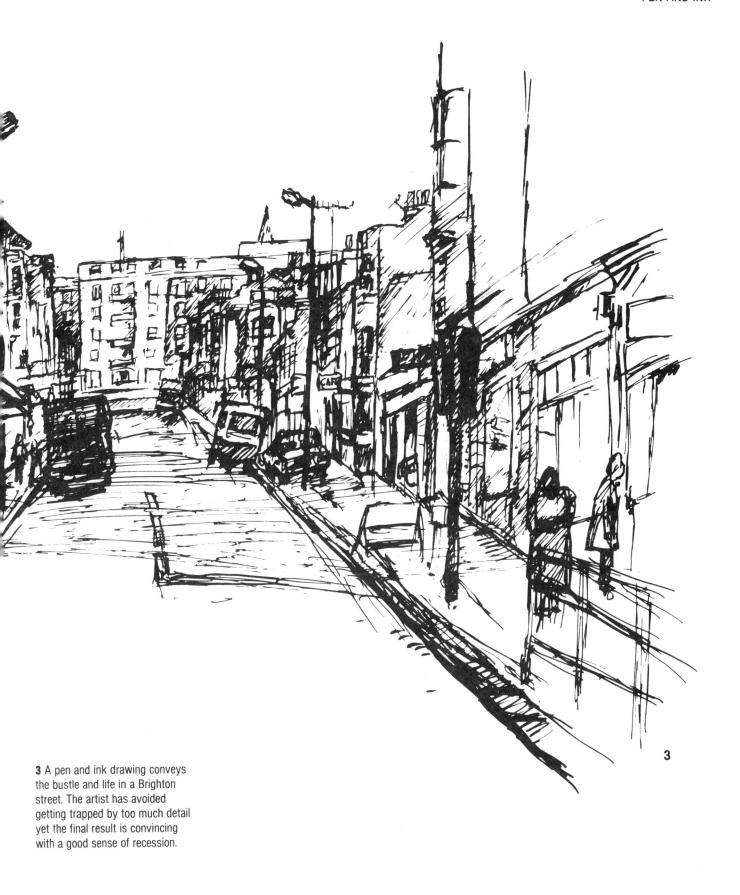

WATERCOLOUR

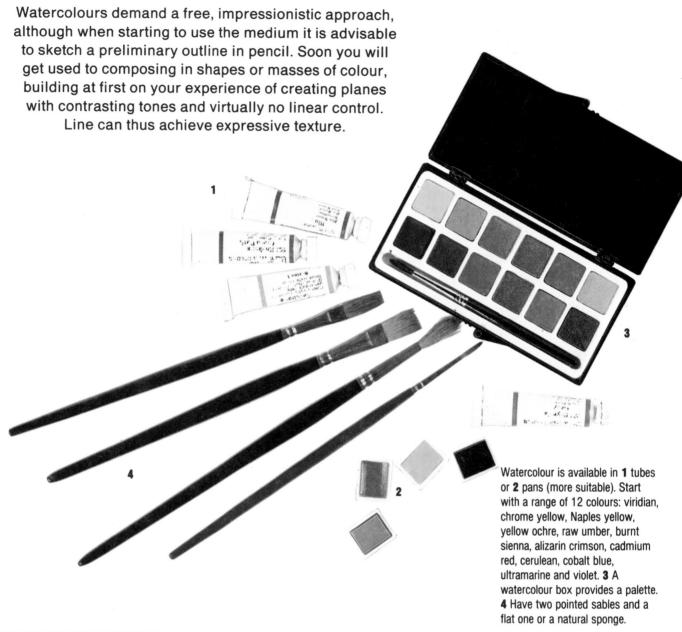

Mixing a wash

Dip a sable brush into clean water, shake out then dab on the colour and transfer it to the palette.

Test the colour on a spare piece of the same paper as you are using the surface affects the colour.

Mix up enough of one colour for a wash. Clean the brush in fresh water between different colours.

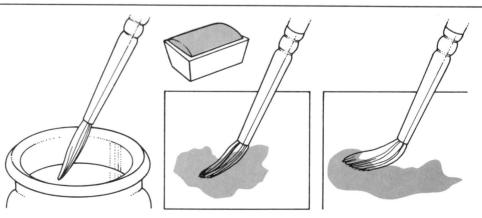

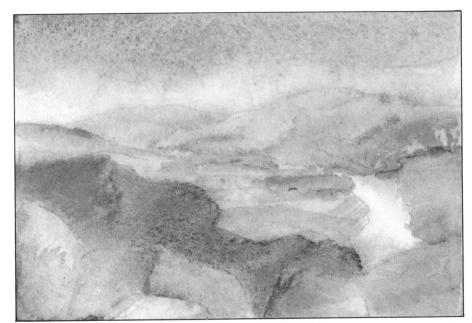

Wet on wet method to create blurred edges. Pencil in the main shapes then soak the paper with water with either a wide brush or a sponge. Work the colour into the wet surface, starting with the lightest colours. If the paper starts to dry re-wet it with a brush.

Dry wash technique retains crisp edges. Rough in the outlines in pencil on the stretched, dry paper then brush in your washes starting from light to dark and allowing each to dry before applying the next. Work on two or three drawings at a time if you like to work quickly.

A splayed brush is useful in creating a kind of shimmer, especially in foliage. Pinch the hairs of a brush loaded with fairly dry pigment, so that they splay out, and draw the forms freely. Make use of the parallel lines this technique tends to produce revealing the underlying wash.

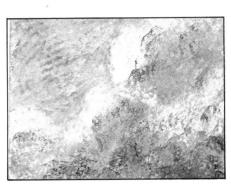

For the sky, or for a distant wood, try applying a number of washes with a sponge. Dissolve the colours into pools on the palette, then dip in the sponge and apply lightly to the paper. You can achieve bold shapes and the tiny bubbles introduce a new textural variety.

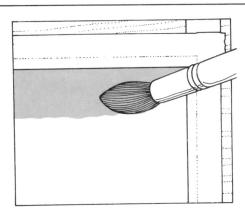

Laying a wash

The key to successful watercolour wash drawings is the ability to work with speed and confidence. Remember to work from light to dark – the process is irreversible since the washes are transparent. However, the colours do lighten as they dry. Stretch the paper (see p 112), while still damp tilt the board at an angle and mix a large quantity of dilute watercolour. Load a large, soft sable and brush in long, even sweeps across the paper, going over the edge of the paper at each end and catching the tear of colour from the previous stroke.

1 This drawing demonstrates very clearly how successfully one can indicate detail in a watercolour without the painting becoming tight or laboured.

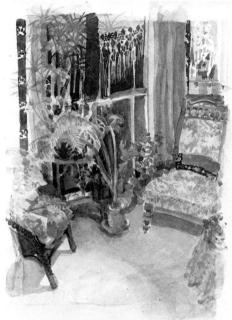

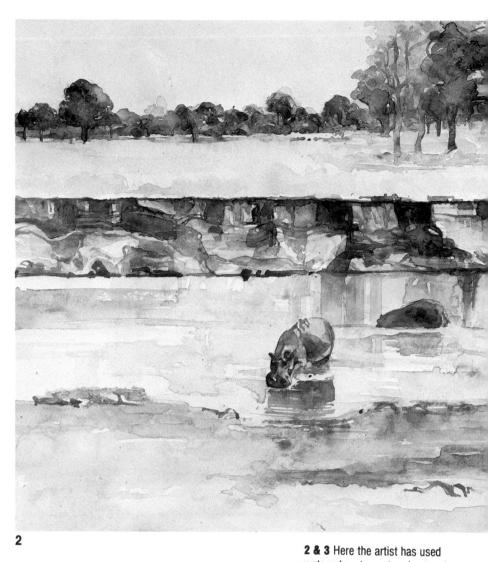

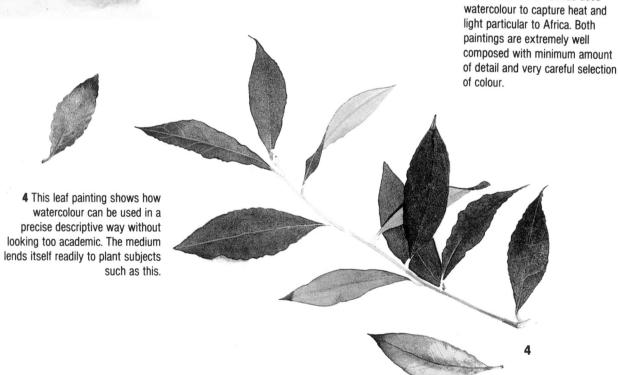

1

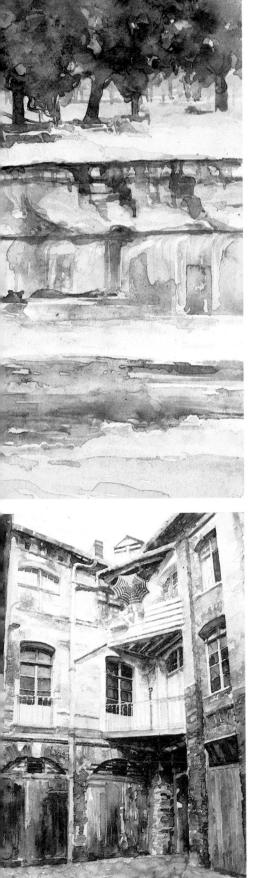

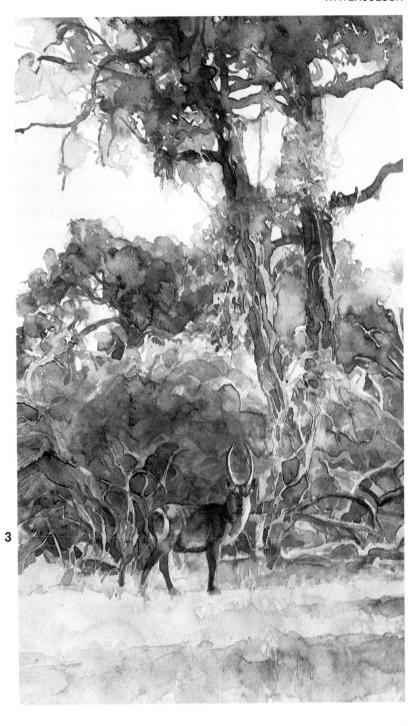

In this architectural painting watercolour conveys a very real impression of the patina found on well used old buildings. The artist has concentrated on atmosphere as well as detail to give the finished result and individual style.

THE WORK AREA

It is a straightforward matter to make a drawing board from softwood, or composition board which can be cut with a craft knife. The wood will take drawing pins and does not chip or warp. Hardboard is an adequate material to use and is inexpensive but masking tape or clips will be needed to fasten the paper to a hardwood board. It will require a pad of several thickness of paper to cushion the drawing surface, rather than a single sheet of card, all that is needed with composition board.

If you intend to buy a drawing board, do not economize on quality. Cheap boards tend to warp. Heavy duty ones are usually metal edged or are battened at the back. Table-top models are adjustable from a horizontal to a nearly vertical position.

The light by which you draw is of fundamental importance. Artificial light will cast deep shadows, and even natural light can be an impediment if the shadow cast by your drawing hand falls across the paper. The drawing board should be vertical to avoid distorting the perspective. When you are setting up your subject make sure you leave enough space to view it from every angle.

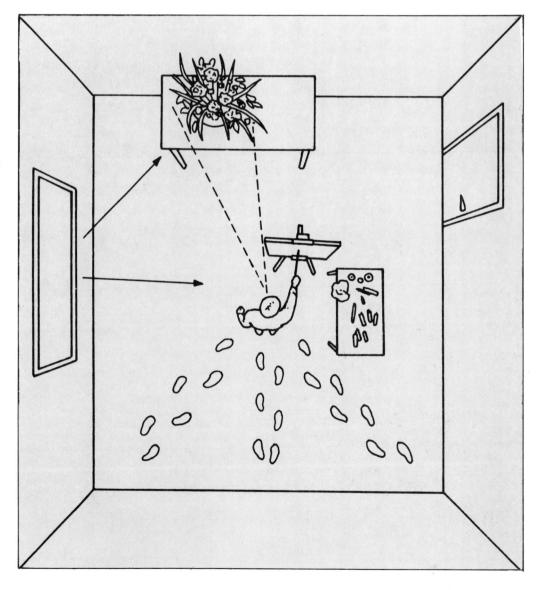

Attaching the paper to the board Protecting your work

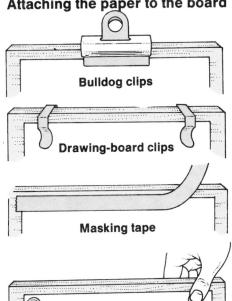

Eraser rubbings can be whisked off the drawing surface with a large, soft-bristled brush. Water pots or ink bottles should stand well clear of any drawings or sketchbooks and kitchen paper or cotton buds should be within reach to mop up spills. Keep a jar of water clean for dabbing on any ink spills with a soft brush, then when the surface is dry rub out the stain.

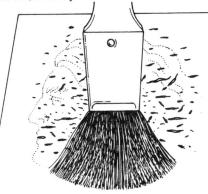

How to erase

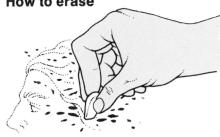

Most media can be erased if you know which tool will do the most effective job. Pencil is removed effortless with an ordinary India eraser but there is a possibility of smudging. To help with the problem, cut it into a trangular shape to produce a fine

Organizing the work area

Drawing pins

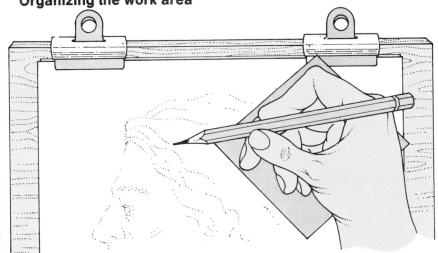

When drawing still life, portraits of your family and friends, or even a model in a life class, one definite advantage is that of being able to view the subject from all angles. It is impossible to walk around behind a landscape or a row of buildings as if it were a film set. A still life neither moves nor breathes so it can be inspected closely and at leisure.

Place the board vertically so that what you see in front of you will be interpreted on the paper without any distortion. If the board is sloping away from you, then every plane or curved shape will assume new and unreal proportions. Your line of view should strike the paper at right angles. Position yourself so that your arm extends comfortably, neither cramped not rigid, or your back will quickly begin to ache.

When you are working close up on small or highly detailed drawings, a piece of acetate or clean cartridge paper under your hand will keep the surface clean and free from marks.

edge. Charcoal responds to fresh white bread rolled into a ball, or a kneadable putty eraser which does not damage the paper. Special shields or acetate will protect the rest of the drawing from smudging.

Cleaning erasers

Erasers collect a great deal of grime if left loose in a drawer. Hard erasers should be cleaned on the corner of the paper from time to time. Putty erasers can be cut into smaller pieces or the frayed threads removed as you go.

TECHNIQUES

Drawing is the most immediate way of representing something visually in two dimensions. The choice of subject, the view, the emphasis, mood and the materials used all help reveal the artist's experience of the world.

Enjoyment is most important and it will show in your drawing.

Develop your awareness by drawing and sketching constantly to record the observations you have made. Try different approaches, whether in terms of scale, materials, or subject matter – this will develop your ability to see and your confidence.

The exercises, examples and tips in this section will guide you through any problems you may encounter, giving simple ways of understanding them. Suggestions are made for methods and approaches – use those that appeal to you.

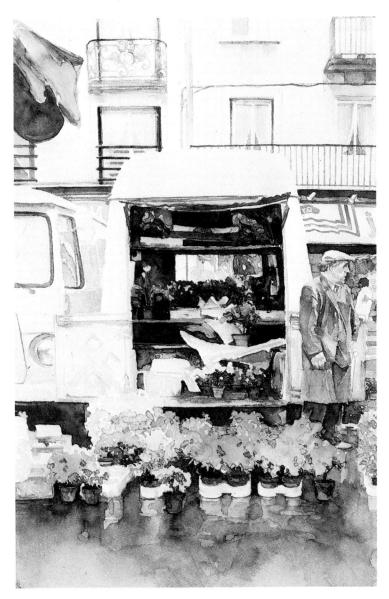

Water colour on slightly textured paper.

DRAWING WITH A GRID

Drawing is about observation and training your eye to send a message to your hand to represent the three-dimensional on a two-dimensional surface. Unless the eye is trained no amount of deft pencil strokes will convey the true form of an object and its relation to the space around it. To sharpen your powers of observation and to really *see* what you are drawing, start by limiting what you put to paper by considering only the outline. With the aid of a grid you will be able to plot shapes in relation to one another. By limiting your expectations of the finished drawing you will intensify your concentration, begin to understand the problems of proportion and shape and get a feel for the materials you are using.

Drawing a grid

Rule up a sheet of paper larger than the subject. Using a ruler and set square, divide the sheet into 5cm squares with a soft pencil (2B or 3B) so the lines show well.

Take a sheet of smooth cartridge paper for your drawing and divide it up in the same way. Use a harder pencil (HB) to contrast the grid lines with the drawing.

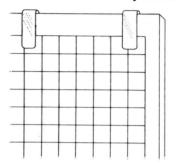

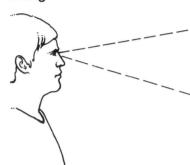

Setting up the subject

Choose a subject, such as a pot of flowers, and put it on a table about 1.5m from where you will stand to draw. Far enough to see the plant as a whole; near enough to see the detail. The plant should be a little below eye level so you can see how it grows. Set up the drawing board vertically on the easel; if it slopes it will distort the drawing (see p42). Take up a comfortable stance behind the board and mark the position on the floor to keep a constant viewpoint.

Drawing the subject

Glue or pin the grid to a board and place it vertically behind the plant, propped up by books or against a wall. The light should fall on the side of the plant to make the definition of the shapes easier to read. Observe the outlines before you start work; notice the contrast between the different lines. Simplify in your mind what you see and think in terms of recording the silhouette; do not try to convey texture and tone at this stage.

Using a 2B pencil held loosely, not too near the point, start drawing a simple shape — the outline of the pot; notice the space left on both sides of the line. Move on to the more irregular shapes of the leaves, choosing simple shapes first. Plot in lightly their relation to the pot through the axes of the stems, tracing the direction of growth. Once you have an overall outline begin to explore the more detailed shapes, relating each line to another within the same square. This will enable you to describe receding lines by accurate observation of the angles they make on the grid.

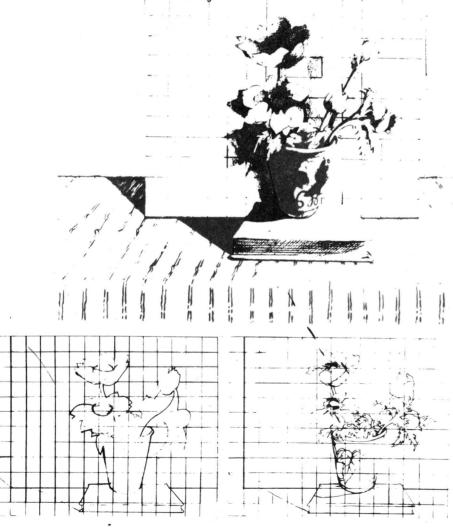

Having imposed a drawn-up grid on your subject you will begin to realize that everything can be seen in terms of its relationship to its setting. The horizontal and vertical lines of structures that are found around the house, such as table edges and window frames, as well as those outside, can be used in your drawing as a kind of grid that you will find rather less restricting than one that you have drawn up with a ruler and set square.

Choose your subject and set it up against this 'natural

grid'. Then start your drawing by plotting in the horizontals and verticals lightly, using a loose extended arm movement to draw the straight lines. Try to avoid using a ruler as this will tend to give a mechanical effect to the drawing. Use the straight lines to help you see the outline of the subject and notice where all the lines intersect. If you feel confident about the shapes you are making, try experimenting with varying the weight and character of the line to introduce volume.

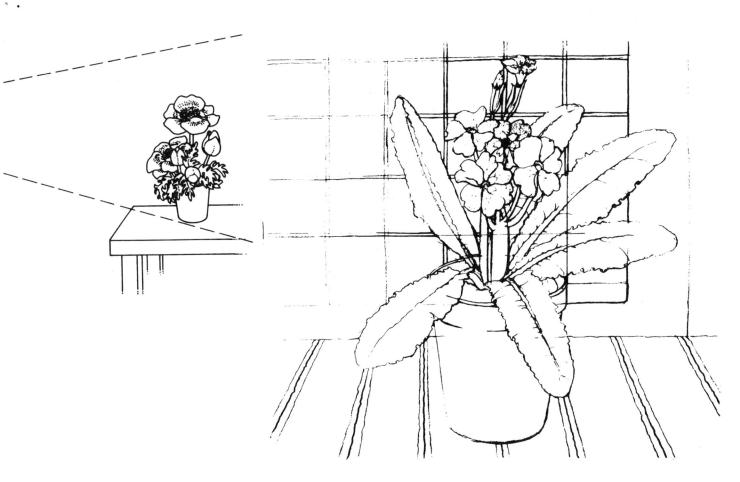

Drawing the subject (against a natural grid)

Compose your picture by choosing an object whose shape will contrast with the straight lines of the background. Start by drawing in the natural grid of the background with particular attention to the accuracy of the verticals. Unless seen front-on the horizontals will be affected by perspective, as seen in the stripes on the cloth. Treat this sort of problem as pattern for now and use it as part of the grid. Draw in the main shapes of the plant, considering overall outline helped by plotting in the main axes of the leaves. When the outline is right, convey a sense of volume by varying the weight of the line: give more emphasis to lines in shadow, erase areas to give highlights.

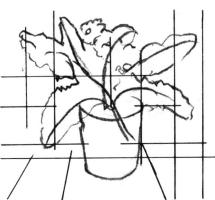

PLANES AND SIMPLE TONES

To explore a three-dimensional form it is helpful to start off by drawing rectangular objects so that the eye understands the shape immediately and does not have to sort out the subtleties of the planes of organic objects. By setting such things as cardboard boxes and books (which you know have a top, side and front to describe) in a natural framework of horizontals and verticals you will be able to relate the edges more easily and this will leave you free to learn how to describe planes.

A single line can imply solidity and this is more obvious with angled shapes than with curved ones – you know that there is another plane on the other side of the line. The addition of tone confirms the change of angle and hence the change in the angle of light.

Horizontal and vertical quides

Arrange three or four objects on a table placed squarely in front of you, with the front planes facing you, a little below eye level.

Consider the relationship of the horizontals and verticals of the objects in relation to one another and to the angles of the table, observing the way they overlap and the shadows they create. Now add more objects to your composition and change the light source.

If you find when you compose your arrangement that you are distracted by the labelling on the books and boxes, give them a coat of white paint.

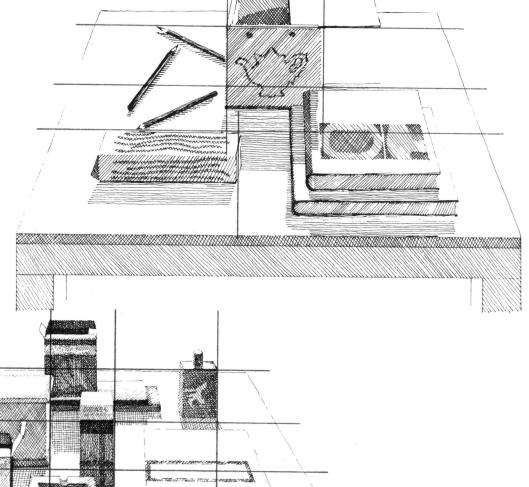

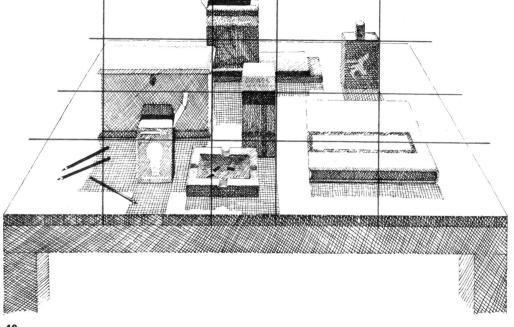

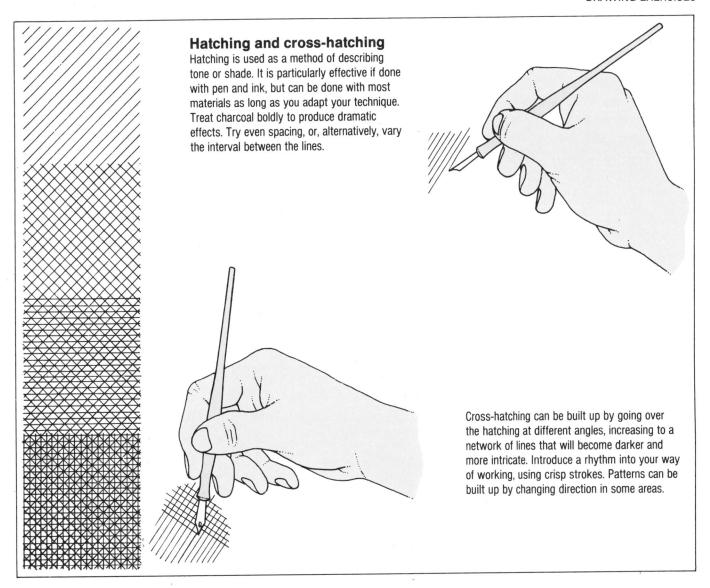

Vertical guides

Vertical guidelines remain constant. Move the table at an angle, rearrange your composition and relate the objects to the verticals of the table legs. If the front faces of the objects are still aligned with the edge of the table you will now see two sides, or planes of the boxes as well as their tops. You will not be able to rely on any horizontal alignments and tone will come into play to describe form. Use two different intensities of cross-hatching to describe the surfaces and the shadows.

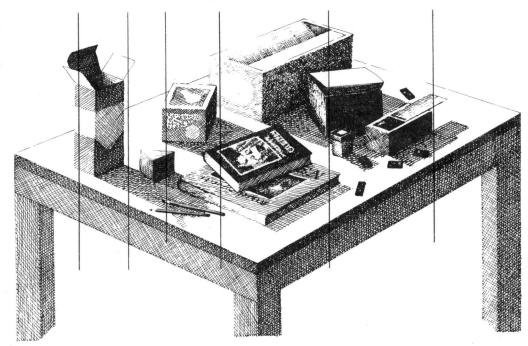

SIGHT SIZE AND SCALE

The field of vision that the eye takes in is in the form of a cone, known as the 'cone of vision', the apex of which is at the centre of the eye. It is easier to draw on what is called the scale of vision or 'sight size' since the mind is not concerned with interpreting scale and doing complicated geometrical enlargements or reductions. You will find that you tend to draw naturally at sight size. Scale in drawing is concerned with the distance the artist stands in relation to an object, which determines the size it is seen. If you hold your hand in front of you at arm's length and gradually retract your arm, your hand will seem to grow larger until it passes out of focus as a whole and only part of it can be seen. This concept is formally organized into the science of perspective.

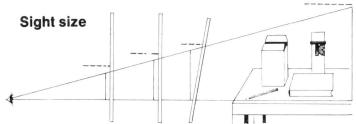

The size of your drawing will be determined by the distance that you and your drawing board are from what you are drawing. The nearer the board is, the larger the subject will appear; the further away you are the smaller it will appear. You will find by experience where the most comfortable distance to stand from the subject is (about 1.5m is generally suitable). Remember to keep your drawing surface vertical to avoid distortion. At sight size your drawing will appear on the drawing board at the size it would be seen if the board were a piece of glass and the image seen on the plane. To help your understanding of this idea you might want to try doing a drawing on Perspex (see p86). It will also help you to transfer lines that are seen at difficult angles.

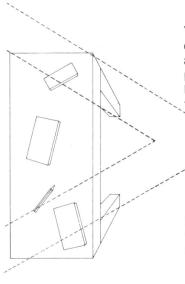

Your 'cone of vision' takes in everything within a 60-degree angle on a horizontal and vertical plane in front of it. The further back you stand from the subject the wider the area you see in focus will be. If you move your head to take in more than what is encompassed within your cone of vision you will be composing a picture from a multiple viewpoint and it will be distorted. Be aware of this when drawing landscapes and do not take in too wide a view.

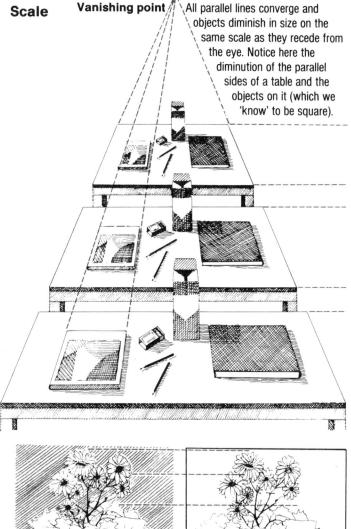

If you train your eye to see accurately you will gradually become accustomed to judging proportion and scale and the relation of one thing to another in a composition. There are devices that will help you to check the lines that you draw and these can be useful, but try to rely in the first instance on your own observation and use these

Measuring with a pencil

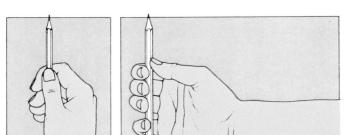

Above: Hold the pencil upright in your hand, steadied by the thumb and gripped firmly by the fingers. When measuring verticals the thumb should be uppermost, for horizontals the hand is held level. The arm *must* be fully outstretched so that comparisons are constant. A ruler or piece of card marked with the units you want to compare can be used also.

Above right: Find an edge that you want to measure in comparison to another line that appears to be a similar length. Line up one end of the pencil with an edge of the near object and mark the other edge with your thumb. Now move your hand, keeping your thumb still and compare the length marked by the pencil with the further object (holding it at arm's length). This method will work only within the range of your cone of vision

methods only as a means of double checking. It can be surprising to discover how the mind tends to read objects of a similar size as occupying the same dimensions irrespective of the distance between them. By measuring with a unit of comparison that is closer to your eye you will find out about perspective and foreshortening.

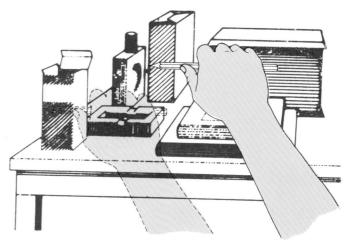

as your arm acts as a pivot from your shoulder and describes the arc of a circle. Measurements made at the extremes of this limit would not relate to the flat surface of the drawing. Begin by measuring regular-sided objects; the contours of rounded objects are more elusive.

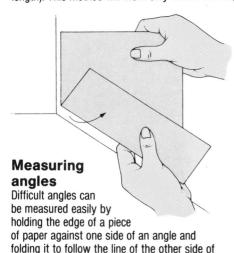

Drawing by direct transference

checked as it has brought it into the same plane

the angle. The paper can then be laid on your

drawing or held just above it and the angle

as the drawing.

Left: If you place the drawing board on the same plane as the object the drawing will be exactly the same size as the object and it will also be sight size. It will be easy to draw since your eye will not have to interpret scale and since you are so near your subject, minimal time is lost between looking at the subject, memorizing it and transferring it onto the paper.

Using imaginary clock hands

Another way of judging angles, though relying more on judgement than on practical short-cuts, is by imagining the hands of a clock superimposed on the angle. This will reduce the scale and bring it into a closer plane.

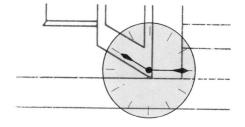

Measuring with a plumb line

A plumb line is a useful and accurate way of checking verticals and spotting what lies vertically beneath them. It is particularly useful in drawing the figure and in helping to determine the main axis of the body. A plumb line will correct any bias of vision that your eye may have in judging the position of the vertical (this can often be a surprising discovery). It will also relate parts of your drawing, from the back to the front plane.

A plumb line can be made by tying a small lead weight (a fishing weight, a tube of paint or some keys) to a piece of string or fishing line. The weight should be just enough to keep the cord taut. Hold the plumb line out in front of you and regard it as a portable grid to check the edges of objects and line up things that appear to lie above or below each other.

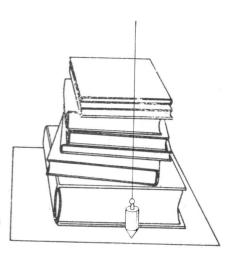

DEFINING FORM

Tone is used to show direction of light and changes of plane on objects; it is a way of suggesting solidity and the illusion of the third dimension. In simple objects, such as cubes, a change of plane is always revealed by its angles and a simple change of tone which can easily be translated onto paper. In rounded objects the tone must be 'modelled' by following the curve of the surface as it turns from the light.

The use of tone

Cubic shapes can be described in linear terms; perspective and the relation of horizontals and verticals give enough clues to its form, although when the object is at eye level and part of the shape is not seen then tone is helpful. Cylindrical shapes can be understood when a cross-section is visible. As soon as it is not, it becomes incomprehensible to the eye and modelling must be used. The outline of a sphere, being the same from any angle, relies totally on modelling to define its form.

Light on a curved form

On a spherical object the light falls in a diminishing degree of brightness as it moves around the form from light to dark. At the centre and highest point is the highlight. Next to this is the broader main, or direct light, graduating down in tone as it moves from the highlight becoming darker until it begins to lighten up again by picking up indirect, or reflected light from nearby sources. It then casts a shadow, one cast by artificial light being sharper than a daylight shadow.

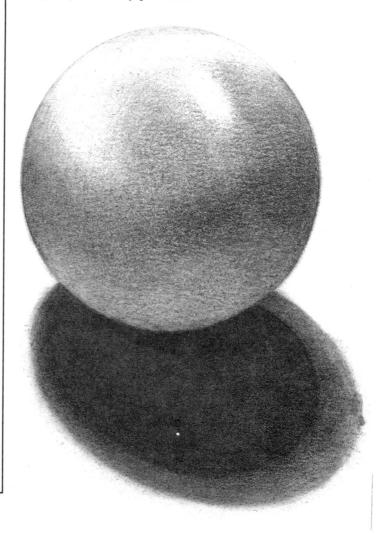

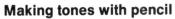

Lightly shade all the areas that you want to be toned with a 2H pencil. Increase the pressure of shading with the same pencil in the areas that you want to be darker. Lightly rub with the finger to soften the tonal gradation into the surface of the paper.

Remove light areas with a putty eraser, working slowly. The surface is now smooth and more responsive to increased toning with a B or 2B pencil. For a very dark area use a 4B. Dark tones can then be polished up by using an H pencil.

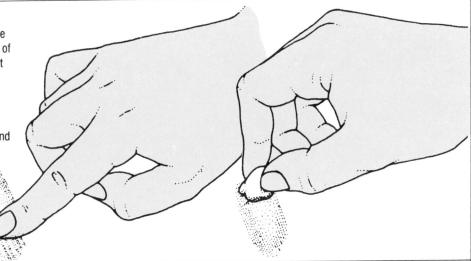

Simple forms

These four simple shapes are the main basic forms to be found in nature and can be used to simplify your understanding of any still life object, figure, tree or flower. Proportions of any scale, from a flower right up to

a building, can be worked out in simple three-dimensional terms. It was the great artist Cézanne who said, "Treat nature in terms of the cylinder, the sphere, the cone . . . "

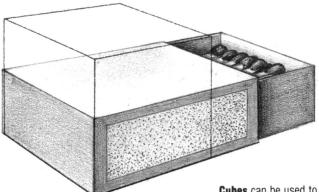

Cubes can be used to work out the basic shape of any regular sided form – a matchbox, a building.

Cones are found in many organic forms; look at flower heads, carrots, or poplar trees.

Cylinders will describe the structure of a flower stem, tree trunk, a leg, or an arm.

Spheres and their sections are seen in apples, tomatoes, cabbages, wheels, or umbrellas.

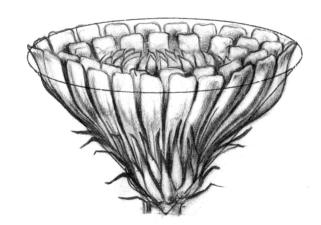

DRAWING A STILL LIFE

Whether you intend to draw a still life for the sheer enjoyment of the shapes, as a study for a larger composition, or simply as an exercise, you will find that this relatively simple subject opens up many interesting possibilities and poses many challenges. You may be tempted to draw an existing composition of 'found' objects or to set up your own arrangement. Explore the range of materials available to you; your choice will depend on suitability and on the character that you want your drawing to adopt, but more immediately on your mood.

Composing a still life

Vegetables and fruit make a very good subject for a still life. Their shapes and textures are pleasing, enhanced by their colour which you might like to try to convey at this stage, or later, when you have first understood them in monochrome. A practical consideration when choosing fruit is their life expectancy: tomatoes and aubergines last well,

carrots and mushrooms, on the other hand, tend to wilt quite quickly so make individual studies of these to keep for future reference. The background is as important as the main subject; introducing a patterned wallpaper or tablecloth will break up flat surfaces. Make the composition easier to construct by including the vertical lines of, say, a chair back.

Consider the direction of the light; daylight is more subtle, but remember that the direction will change as the day goes on, artificial light creates sharper shadows. Do you want the composition to be contained within the rectangle of your paper or to break out from it? Make preliminary sketches from a number of different viewpoints.

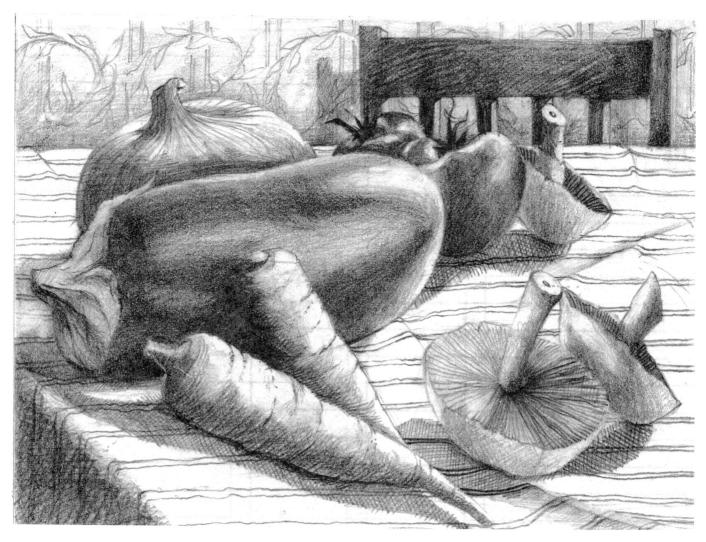

Investigating the subject

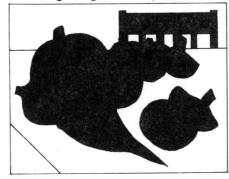

Consider the shape of the group you have arranged on the table. It may look pleasing, but the eye takes in everything and is not selective as your drawing will be. Do several quick sketches of the outline made by the shapes as a mass, shading in the solid areas. This will emphasize the positive and negative shapes created by the composition, their relation to the background, and their position on the paper. Alternatively, you might want to shade in the negative shape.

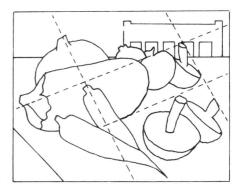

Now consider the individual shapes. Draw in the outline of each of the vegetables and place them in front of one another on the paper, at the same time building up a sense of direction that draws you into the composition. A diagonal force made either by the objects or by the space left between them will open up the picture plane and take the eye into the composition. Create a foreground, middle and background — it is possible, even on such a small scale as this.

Starting to draw the group

1 Having chosen your materials and found the best viewpoint start plotting in your verticals and horizontals and then the main geometric shapes. Draw in the whole shape of the vegetables to check they really occupy the space you suggest. Emphasize roundness by adding contours.

- **2** Begin to emphasize the stronger edge and add tone and the shapes created by cast shadows. Tentatively add in detail that gives clues to the character of the vegetables; the delicate gills of the mushroom, the gritty, whiskery lines of the carrot, the smoothness of the aubergine.
- 3 Now work up the texture and tones. Vary the quality of the line; if you cannot see an edge do not draw it in (notice where the top of the carrot touches the aubergine the forms are understood). Do not lose any delicate detail. Lastly add the decorative pattern of the tablecloth.

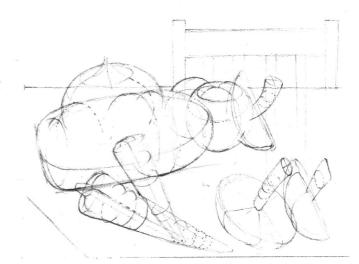

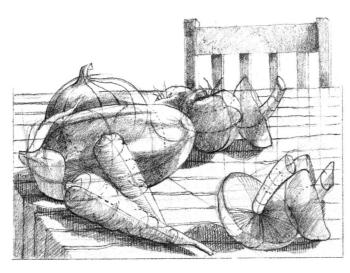

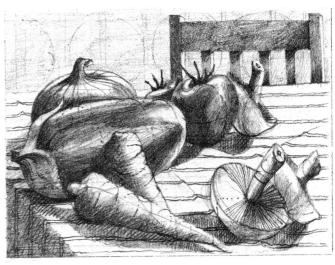

FLOWERS

A single flower or leaf, a bowl or arranged cut blooms, a bunch of wild flowers or a growing plant make absorbing and complex subjects. An ability to delineate outline and mass simply will form the basis of your drawing, but sensitivity in conveying fragility and a feeling of growth will give the subject its beauty.

Making sketchbook studies throughout the year will help you to understand the forms of various species and to see their different characteristics. Composing an arrangement for a finished drawing will set you a time limit. Buds become flowers, leaves will wilt and die. A composition might change enormously if you leave it for a day.

Drawing a flower

A simple understanding of botanical information will not only add to your interest in the subject but will help you to understand the structure of the plant. A careful drawing of one stem will give you the opportunity for detailed observation and to find the best way of gradually building up a drawing of what may appear to be a complex subject. Make things easier for yourself by drawing a single stem, this geranium for instance, against a plain background so that the form shows up well and is easy to see.

1 Choose the best angle from which to draw the plant. Try to ignore the attraction of the colour and texture — concentrate first on form and see the plant simplified to basic shapes. Using a 2B pencil and some smooth white paper begin to put in the main masses, trying to enclose or suggest form rather than trace its silhouette.

The structure of flowers

Flowers are, primarily, functional; their brightly coloured petals encourage pollination by attracting bees and other insects. This cross-section of a geranium shows the radial arrangements of the petals around the reproductive parts of the plant: the stamen (the male element), which releases pollen, and the female element, the pistil (made up of the ovary, stigma and style). The sepals are the outer covering of the original bud.

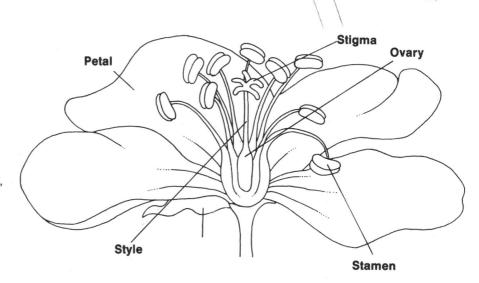

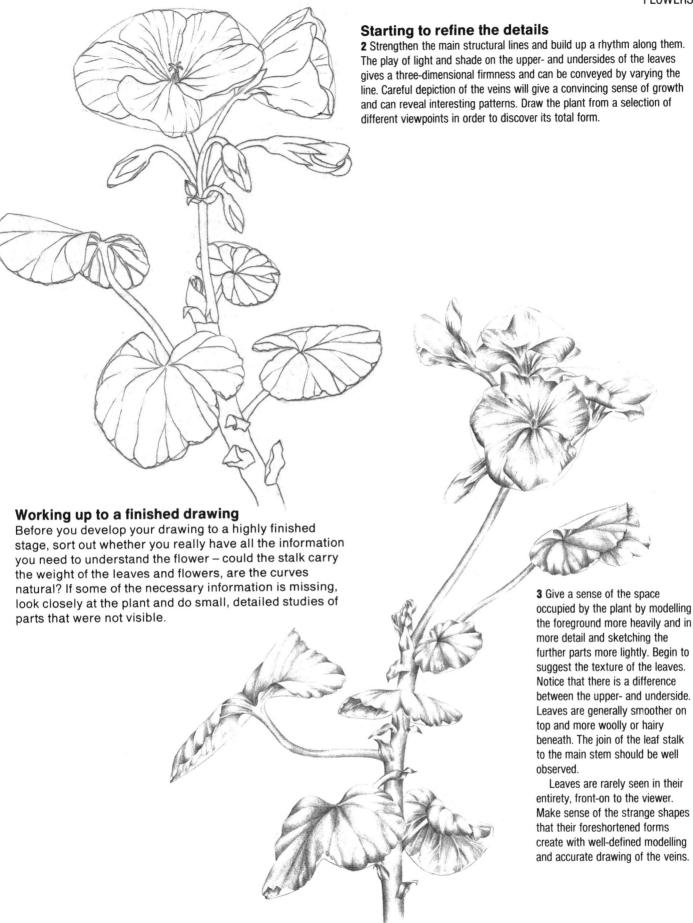

DRAWING THE FIGURE

The human figure has always had a particular fascination for artists. Possibly because the subject is human, it can be one of the most expressive of forms, capable of holding several layers of meaning. In exploring these possibilities, you should look beyond the optical facts and experiment with the rhythms of line and tone, light and shadow. On the following pages the essential skills needed for figure drawing are outlined – first a basic grasp of structure, including anatomy and how the figure moves, and then compositional questions such as viewpoint, pose and the setting in which the subject is placed.

ANATOMY AND STRUCTURE

Knowledge of anatomy is not essential to figure drawing, but it certainly helps. A familiarity with the form of the skeleton will enable you to perceive the underlying structure of a body as you draw it. A knowledge of the elbow joint, for example, will give you a better idea of how the arm moves. On these pages the skeleton is shown from front, back and side, together with the muscles as they are built up and cover the bones beneath. Studying the skeleton should also help you to understand the proportions of the body and how the rigid bones are wrapped up, as it were, by the flexible tissue of the muscles, connected to the skeleton by a system of sinews and tendons. You will be able to represent the body's modelling with much greater conviction if you know where each muscle runs and what it is attached to - what each bulge and curve actually means.

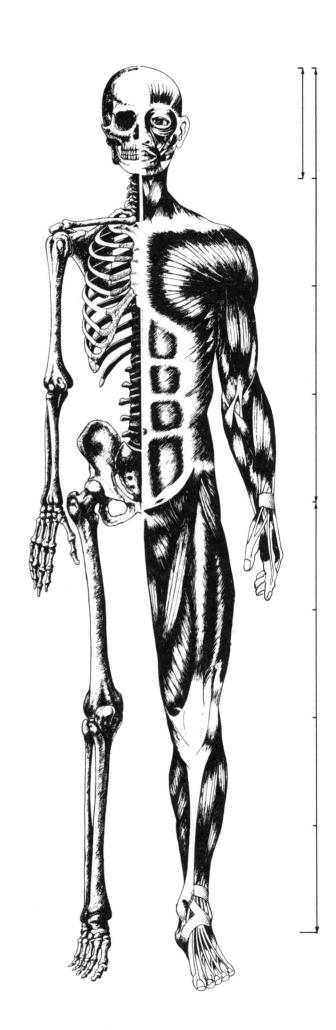

The skull makes up about one eighth of the body's length, and decides the shape of the head. Note the very definite hollows and bumps of the eye sockets, the cheekbones and the jaw.

The neck rises forward from the angled platform of the shoulders and collar-bones. The rib-cage is like a barrel, though the breastbone makes a strong vertical axis. All this is overlaid with complex bands of muscles, gathered in under the armpit.

The bones of the arms change character where they reach the elbow, to form the joints from which forearm, wrist and hand articulate. The upper arm is shorter than the forearm, and reversing this a common drawing mistake.

The pelvis is like a chassis, supporting the weight of the spine and providing a base for the joints from which the thigh-bones rotate. Remember that it tilts as the weight of the body shifts from one leg to the other. And note that the point of the hip is usually found at the mid-point of the body's complete and extended height.

Thigh-bone and shin, together with their muscle forms, meet at the knee. Unlike the elbow, the joint is covered by bone and cartilage.

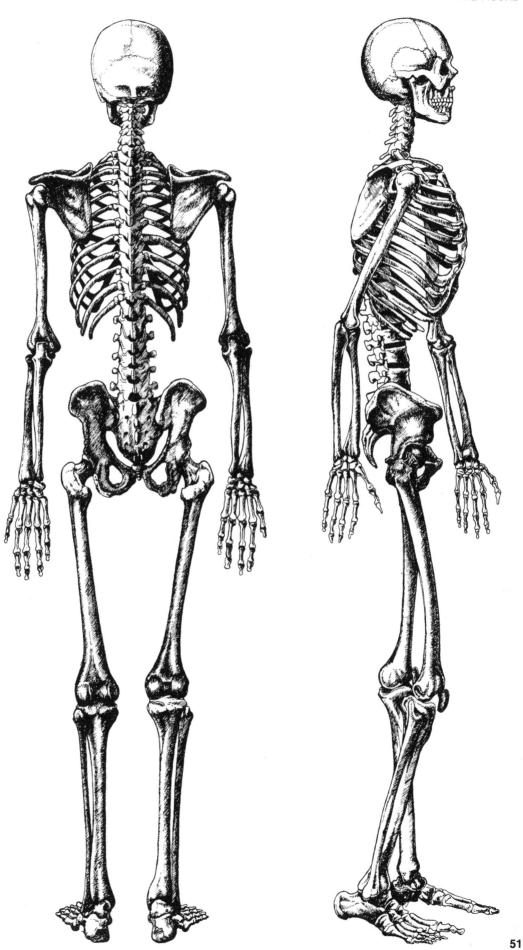

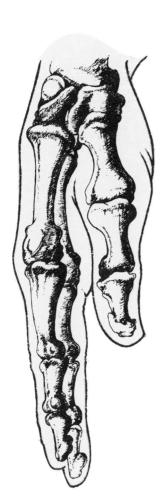

Hands Hands are one of the most expressive parts of the body and by themselves can convey the mood of the entire figure. As a result, they are a crucial element in drawings of the whole figure and can also make superb and challenging studies on their own. Try to think of them as complete structures of bone and muscle and resist the temptation to draw them piece by piece, with the fingers added one by one to the base of the hand. Bear in mind that the finger-bones extend beyond the knuckles into the back of the hand, where they attach to controlling tendons. And note how the thumb is attached at a large joint which is positioned quite close to the wrist.

Male and female shape

There are considerable differences in shape between men and women. and minor changes to the outline with which they are drawn can convey a great deal about their contrasting physical structure. Individuals vary a great deal and it is difficult to generalize. The following points, however, may help in characterizing a clothed figure as male or female. Men are generally larger, and their physical strength is particularly apparent in the upper part of the torso, where they are broader, with squarer shoulders. Women are frequently narrower at the waist, with the whole outline from waist to knee forming a single, full curve. Men may be more slender at the hips.

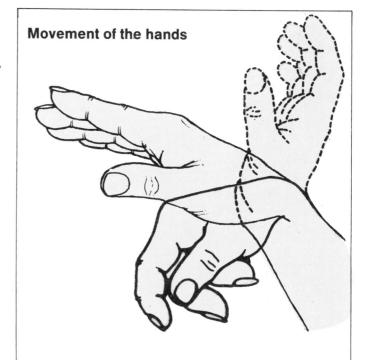

It is all too easy to misunderstand the way in which the hand moves and close observation is the only way to understand all its complex articulations. Note particularly how the hand bends at the wrist and rotates with the forearm. The fingers each have their own movements which need to be studied, especially the thumb.

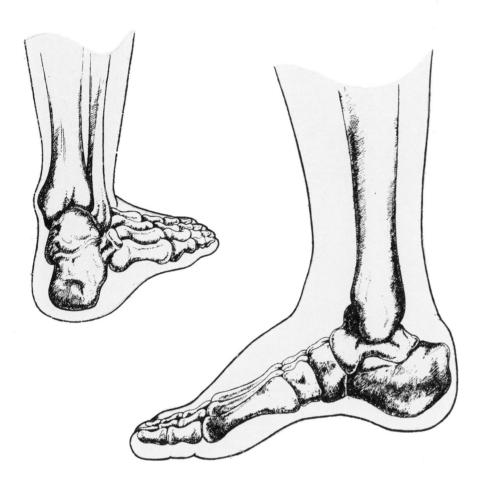

Feet

The feet are less critical than the hands. They are usually covered by shoes and rarely carry the same level of expressive potential. But if you are drawing a figure walking or in a turning pose you will need an understanding of the shape and the function of the joints of the feet. The ball of the foot takes the main weight of the body and is the fulcrum on which it revolves when walking. The ball is steadied by the toes and connected to the heel by a number of small bones which form a flexible arch. Remember that the feet always act in concert, balancing the body between them, and the movements of one are usually reflected in the other.

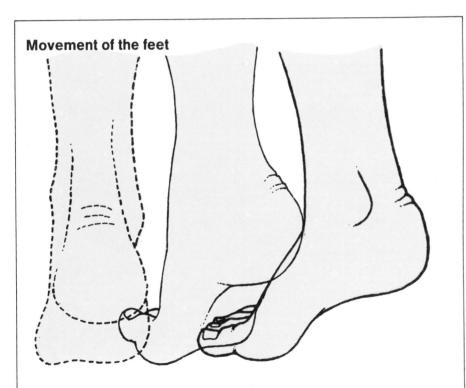

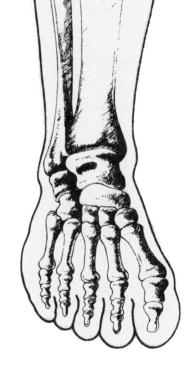

As the leg moves forward, weight is transferred from the heel, through the ball of the foot to the toes, which form a kind of platform. Note that the feet are normally set obliquely to the leg rather than pointing directly forward and that the ankle-bone is higher on the inside of the foot than the outside. Study the way the foot bends at the ankle.

Head

A drawing of a head is essentially a portrait, so even the smallest changes will affect the personality that emerges and certainly have a great influence over the degree of likeness. At first, however, ignore these considerations. Concentrate on the structure, building up the head from its main features — eyes, nose, mouth, ears and hair. Study their relative positions and scale, leaving the details of expression or personality until later. An important point to remember is that the eyes are at the mid-point of the head and that the base of the nose is about one-quarter of the distance from the chin.

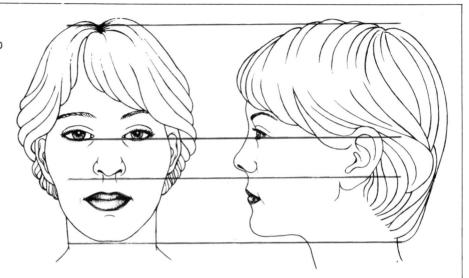

Finding a pose

Simple full-face and profile drawings have a very formal look — rather like passport photographs. Varying the pose involves greater difficulty with, for example, foreshortening, but a much greater range of expression can be introduced. A glance directed downwards suggests thought, for example, so try varying the viewpoint.

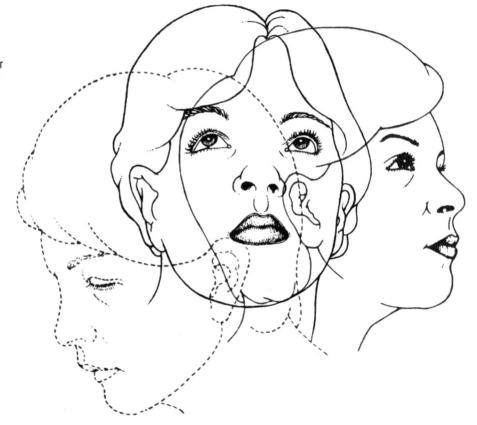

LIFE DRAWING

The nude body is one of the most challenging of artistic subjects. Life drawing teaches a thorough understanding of the proportions and movements of the body and develops skill at interpreting and representing solid forms. It was once a central part of an artist's training and some produced studies of extreme technical beauty and expressive power – even in the unpromising circumstances of the academic life studio. Life drawing still has its place, but there is now more emphasis on the creative role of the artist in interpreting the nude figure.

Setting up the model

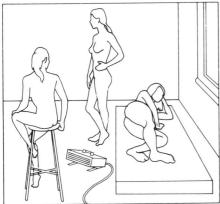

For life drawing, you will need a large, well-lit room, out of direct sunlight and with about two metres space arounc¹ the divan or chair on which the model will pose. Wall lights will cast more interesting shadows than overhead strip lights. Provide a small fire to keep the model warm — this may be necessary even in summer.

Starting to draw: selecting the pose

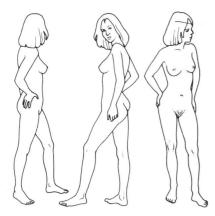

Choose a standing pose to begin with. It will be easier to see the structure of the body and how the weight is carried. Make sure the model is comfortable or it will be difficult to hold the pose for long. Walk around the model before you draw and experiment with the pose. Try to see the figure as a whole, from head to feet as you consider the best angle.

Styles of figure drawing Broken outline

Broken lines do not define the form but suggest it in short stabs and darts. This free style gives a sense of movement and flickering light and shade. It is an effective form of artistic shorthand, but beware of the stylization that can result from loose treatment.

Tonal hatching

Hatching and cross-hatching (described on p41) make it possible to achieve detailed modelling of the form.

Simplified planes

Reducing the body to a geometrical study can be a useful and instructive exercise. Such drawings help you analyse the structure of the body as a construction of surface planes, making you more aware of how the light falls on and defines the solid volumes before you.

Line drawing

The use of line alone creates the most simple type of image, with no attempt to show the modelling of the figure. It is often not as easy an approach as it seems, for the outline has to define the form with firmness if it is to convey the shape of the body and a sense of implied volume convincingly.

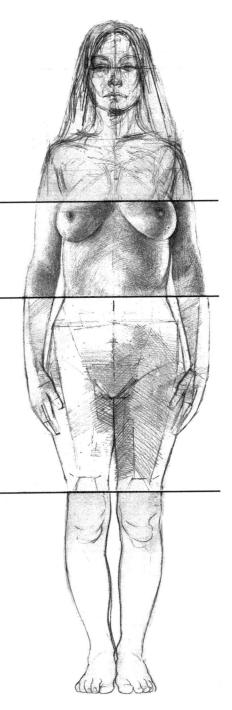

LIFE DRAWING

The best way to take up life drawing is to join a class. Otherwise, you can use a friend or a member of your family as a model, or perhaps hire a professional model with a group of other artists sharing the cost. Once in front of the posed model, look and think before you start work. Draw lightly at first, perhaps swiftly sketching out the complete figure. Take in the proportions of the whole form rather than concentrating on details, working from the general to the specific. Avoid too much correction or concentration on fussy details. A simple drawing will almost always be most effective, so try to make every line count.

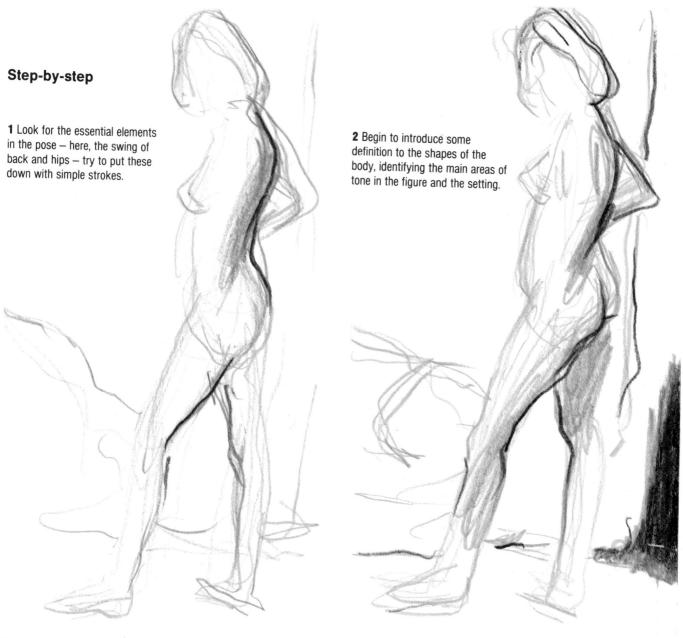

The lay figure is useful for visualizing the body as a construction of simplified forms and for understanding how it moves. Note how the head tilts on the neck; how the rib-cage makes a firm, convex shield; how the hips and pelvis make a bell shape below the waist. Keep this in mind even when you are drawing the figure from the rear, with the shape of the bell flattened out by the buttocks. Consider the movement of the joints of the arm, at shoulder, elbow and wrist. Do the same for the legs, which move not only forwards and backwards but also outwards from the hip. Note how the weight falls — on one leg or both. See how the other parts, especially arms and hands, are used to maintain balance.

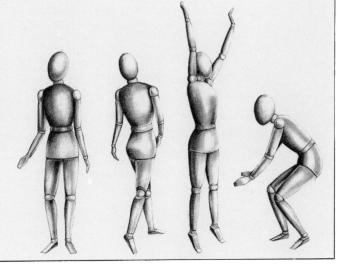

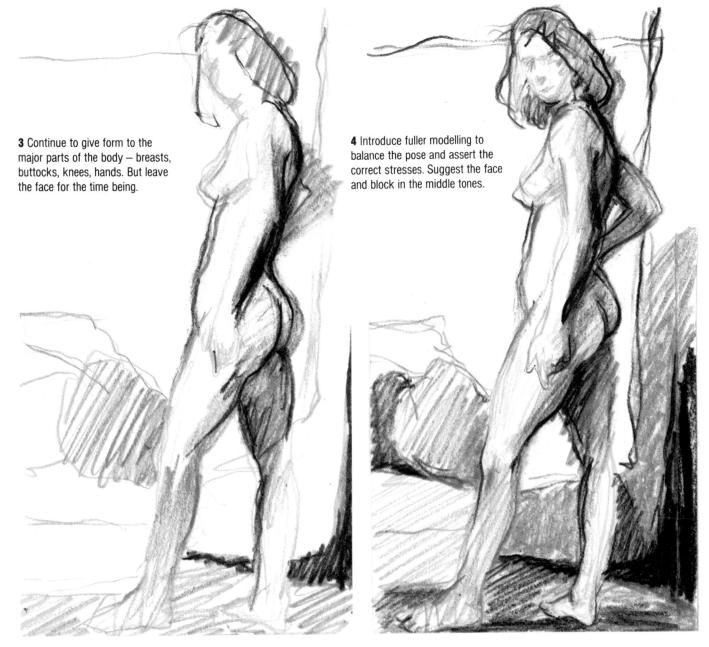

FORESHORTENING

A problem to be overcome in figure drawing is the effect of perspective – foreshortening. This radically alters the body's appearance, and the first task is to draw what you see rather than what you know is there. The solution, however, is not the meticulous delineation of an outline in perfect perspective but the suggestion of the space that the figure occupies. Firm modelling of the forms in the foreground will help. Set off these areas with blank spaces – the imagination will fill in what you have merely suggested. You should also study the drawings of other artists and even photographs to see how the parts of the body change shape with foreshortening.

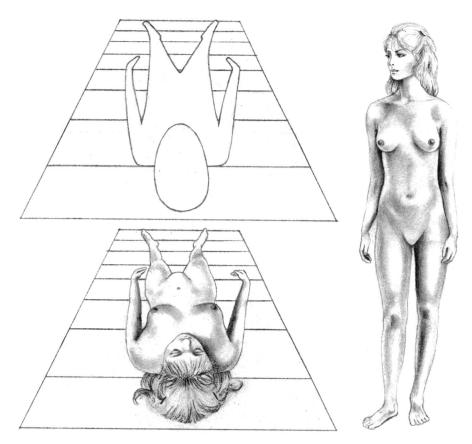

Reclining figures

In practical terms, the problem of foreshortening is to adjust the relative sizes of the parts of the body in relation to the effect of perspective. Train your eyes to see the body's foreshortened shape as a simplified outline, forgetting what you know about the actual size of its parts. If you find this difficult, devise a scale by marking off the main points of the standing figure. Then construct a grid or mark off those same points on the surface on which your model is lying. Having found the overall shape, you must observe the figure before you as a set of solid forms receding from the foreground. In the illustration the modelling of the head and breasts is crucial to the illusion of foreshortening.

Oblique foreshortening

Foreshortening usually occurs at an oblique angle. The same method of measuring as above can be used, although it will be more difficult. More modelling has to be introduced in distant parts of the figure.

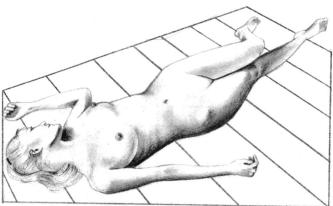

Seated figures

When drawing a seated figure, use the proportions of the chair as a guide. Within this frame, make the points where parts of the body begin or end as clear as possible and let the foreshortening look after itself. The legs can prove difficult, however, particularly when crossed. Use shading to contrast the upper leg with the shadowed leg below. Shading on the arm, breasts and chin adds to the effect of modelling. The chair also helps to establish the proportions of the clothed figure, with the shadows emphasizing the sense of space.

QUICK SKETCHES

As an exercise, try drawing from the life with great rapidity. Ignore the results to start with, for you will be learning something quite different than you would by completing a more laborious study. Drawing at speed forces you to identify the important facts and to appreciate the overall unity of the pose. You will also acquire a much better feel for the energy and movement of the figure.

Start with 30-second sketches, purely as an exercise, timing yourself rigorously. Then move on to one minute. You should be able to produce quite developed and expressive studies. Next move on to two minute sketches. By now, having become here show that it is possible to produce complete figures in this short time, with a

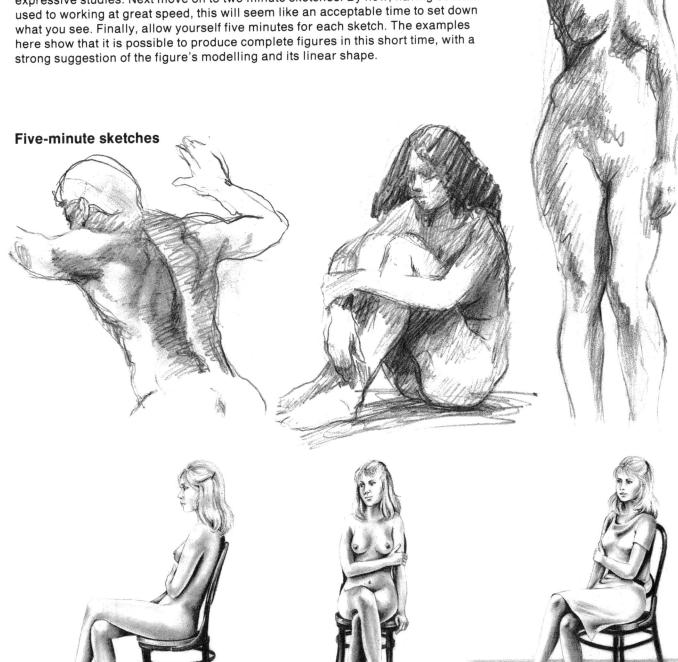

COMPOSITION

Making use of the studies you have made, you can now plan a composition – deciding not just what you are going to include in the drawing but also how best to organize the various elements. The setting of the figure in space and the direction of light are crucial. In addition, the shapes and shadows should be balanced to lead the eye around the composition and give the drawing an expressive impact. Although this quality will be developed as you actually work, it is more likely to emerge if you have a clear conception of what you are trying to achieve at the outset. Try to form an image of the complete composition in your mind before you start and resist the urge to fill in details that attract you until the drawing is nearing completion. Remember that composition comes before style.

Shape and proportion

Relating the subject to its setting is essential. This scene is divided by several main verticals (left). These help define the shapes of the figures and their relative positions in the room. Establish them as the main structure of the composition before starting the figures.

Try to identify the main shapes created by the figure in outline, relating them to the negative shapes around them (right). Both must be pleasing for the drawing to work satisfactorily. These broad shapes are likely to make up the main compositional elements in the scene.

Scale and distance

If your drawing is to include an illusion of space, start by defining the main spatial planes at the front, middle and back — table front, figure and wall behind which closes in the background.

By adding elements to the composition you can elaborate the surface design of the drawing. This may reduce the spatial clarity — perhaps to the detriment of compositional unity.

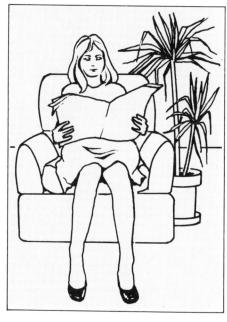

The figure itself may occupy more than one plane. Here, the knees, magazine and head need to be placed in space. Objects, such as the chair, can help to establish these different planes.

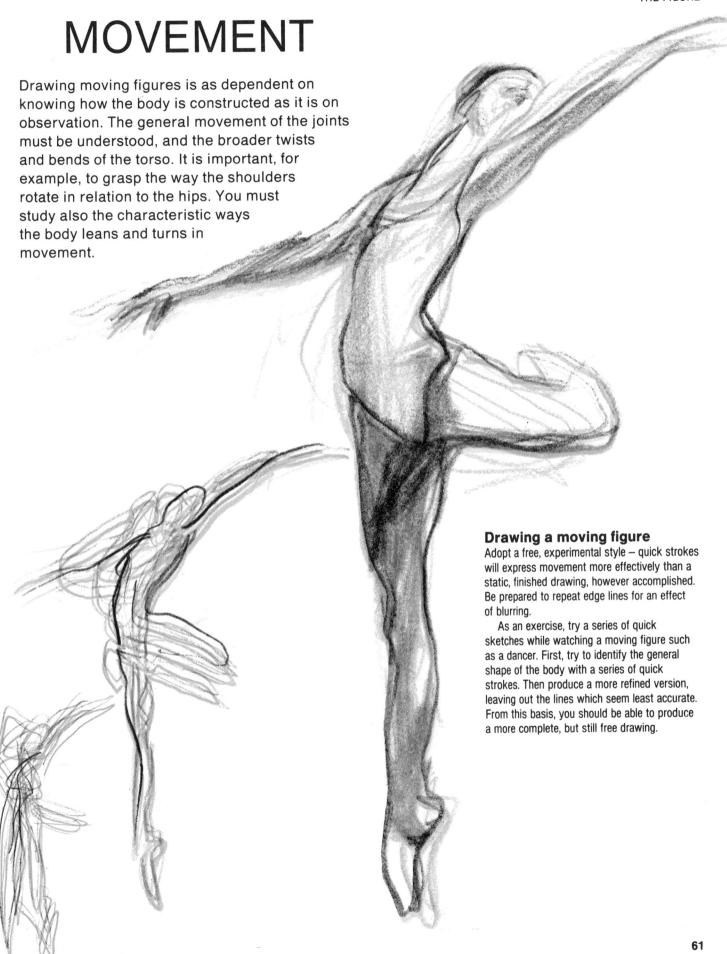

GROUPS AND PORTRAITS

Groups and crowds of figures involve considerable problems, for a group is both a single, broad mass and also a collection of individuals that may need fairly accurate drawing. Begin with a visual analysis of the whole. Is it a compact mass or spread out? What is the difference in scale between the nearest and furthest figures? Which figures come in front and which are partly hidden? When you have loosely mapped out these major elements, choose the figure that seems to be the focus of the composition and establish its scale and relation with the surroundings. Then build up the other figures, always referring back to the key figure and the broad structure you have set up.

Analysing the group

Even in complex crowds, figures can almost always be seen as interacting groups. In this scene, very few figures are totally isolated, and most are engaging companions in conversation or responding to the actions of others in some way. Identify these connections and make them the focus of the drawing.

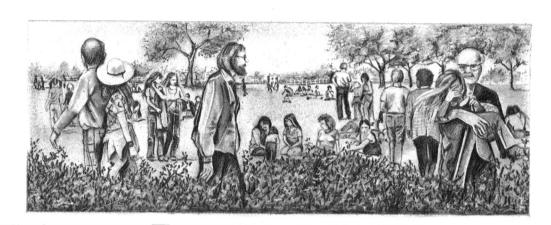

PORTRAITS

A portrait is more than a study. It attempts to do justice to the personality of the sitter. Look at the subject and ask yourself: what is it that makes this person individual? Choose a comfortable pose and give the model a point on which to focus. Allow the model to move around while you are working, however, as long as you can fix the position of the element you are working on at any given time. Avoid fussy surroundings - the main area of interest should always be the personality of your sitter.

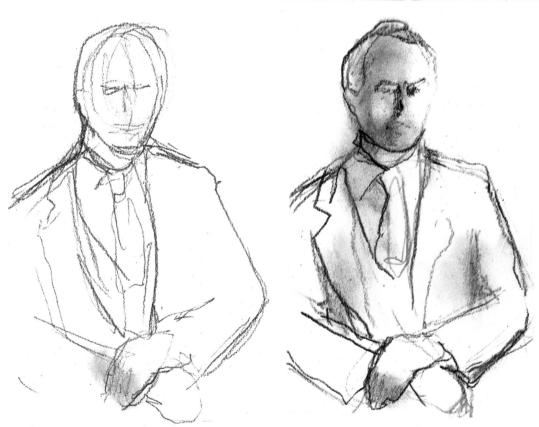

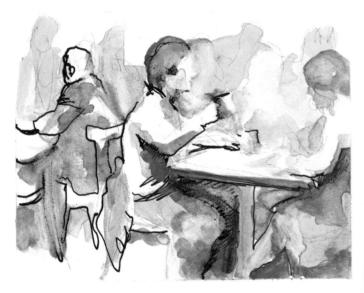

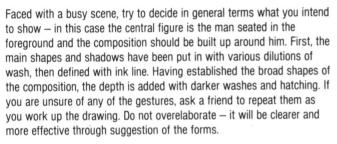

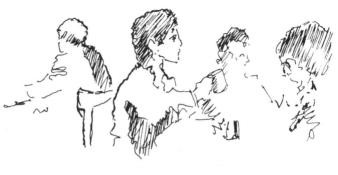

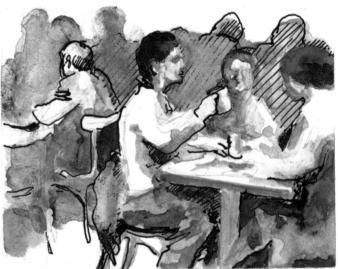

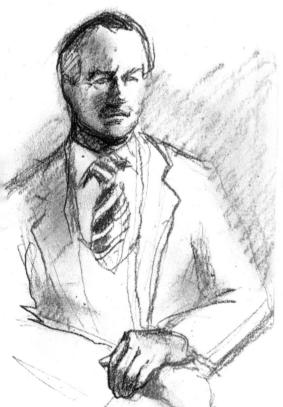

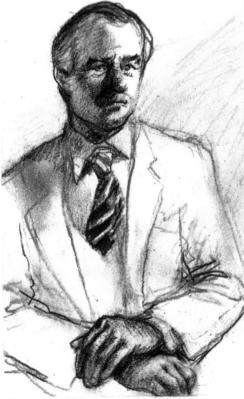

Drawing a portrait

1 Lightly sketch in the general position of the figure, ideally with the head placed off-centre. 2 See how the head sits on the body and outline its shape, positioning the eye sockets, hairline and nose as accurately as you can. 3 Develop the modelling of the form by introducing the main areas of shadow. Then refine the likeness, working on the different features simultaneously so they relate to each other. 4 Next pick out reflected light with an eraser and deepen the shadows.

DRAWING CHILDREN

There are special factors to be considered when drawing children. Their bodies are still being formed and they are so active that study of their structure may seem irrelevant. Indeed, many of the individual and lifelike characteristics in the drawing will come from the choice of a pose that shows some particular behaviour. The shape of the head and the body changes markedly as the child grows, however, and an understanding of this process can be very useful, putting you in a better position to catch the fleeting features of one particular pose. You should match your drawing style to the nature of the subject – a light, swift stroke will be truer than a hard, pedantic line.

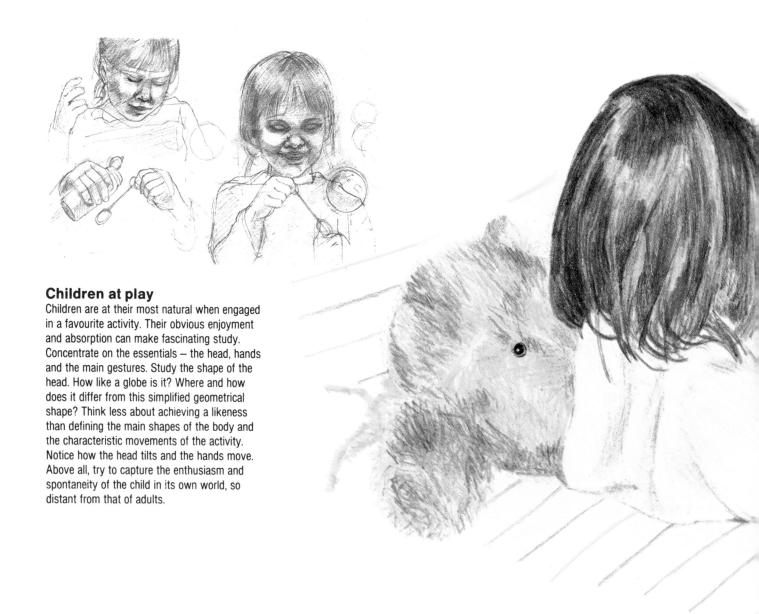

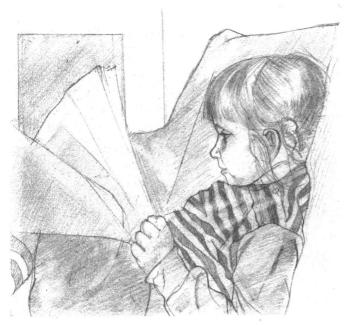

Child portraits are quite difficult. There are fewer individual points such as lines and blemishes to fix the likeness. Note the chubby volume of the cheeks and other facial features. You may also find that children are easily bored and will not hold a pose for long. Try drawing them with something to read (above), or watching television.

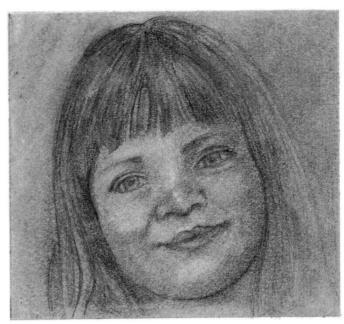

Selecting a medium will probably be influenced by the fact that you may have to draw with speed to capture an expression. Conté crayon (above) is a good 'instant' medium. When used with tinted paper (which establishes a middle tone) it is effective for portrait studies. Pencil sketches (above left) allow for linear variety.

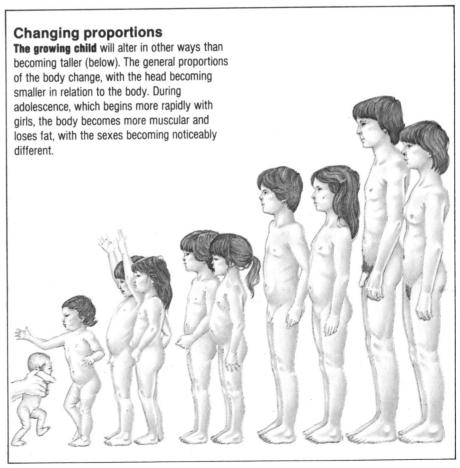

ANIMAL STRUCTURE

Drawing animals presents a problem rather like that of drawing young children as they cannot be asked to pose for you, so you will have to rely on preliminary sketches and a good background knowledge of the underlying structure of the animal. Start by drawing your own pet, which is more likely to keep still for you. If you find that you develop an interest in this subject go on to study the animals and birds on farms, in zoos and in the wild, exploring different ways of conveying movement, character, and the texture and markings of fur and feathers.

The best way of finding out what information you need to make a lifelike drawing of an animal is to do several quick pencil sketches. It may be difficult to determine the basic structure that lies beneath the fur or feathers, or what position the legs are in when the animal is moving. So make detailed studies in museums and zoos. The knowledge will help you work more quickly when drawing from life.

Stuffed animals give opportunity for study at close range. Start by making several two- or three-minute sketches of the whole shape of the animal, trying at the same time to grasp its movement. Go on to make detailed drawings of more complex parts, and markings and texture.

Zoo animals tend to repeat their pattern of movement so work on several drawings at the same time. When an animal goes back to the appropriate position, add to the drawing. The difference between an animal in captivity and one in the wild may be considerable.

Photographs will give you a good insight into movement. The micro-second stills of Edweard Muybridge, revealed in the nineteenth century for the first time how animals really move. Photographs like these will show you the position of the legs and where the weight is

carried. They can, however, be misleading and can give a very artificial appearance.

Anatomical study will reveal the structure and give you a knowledge of how the animal moves.

The spine is the main support. Its design (as the rest of the skeleton) is adapted to the behaviour of the animal. A peaceful grazing animal, such as a cow, is sturdily built, its bones are heavy, a fast animal or a hunter, such as a gazelle or wild cat, has a much lighter structure.

The horse Note that the bulk of the weight is carried by the heavy shoulder bones. The pelvic joints in the rear legs cannot be fully understood from a living animal.

The cat is built for spring, flexibility and speed, powered by its hind quarters. Its spine coils up and extends out, so that motion involves the animal's entire body.

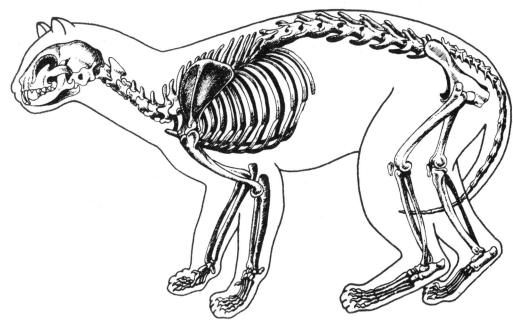

Notice the fine, hollow bones, which are light for flying. Counting the number of wing feathers is useful so that you can indicate them at approximately the right scale.

Birds

A study of a bird's skeleton will help you to understand its mechanics in flight. Notice where the wing joins the shoulder — this is difficult to see even when the bird is resting. For details of feather markings study from stuffed and, if possible, dead birds. Once understood, getting a feel of the rhythm made by the markings will be more characteristic than minute reproduction of detail.

Fish

Beautiful drawings can be made showing the pattern and colour of the species bought from a fishmonger or seen in an aquarium. But if you want to convey movement it is useful to know the position of the fins and tail which propel the fish and the underlying structure. This will remind you that as the body shape changes with every twist, further distorted by the refraction of the water, there is still a bony skeleton beneath.

The fish's skeleton has a large head with the rest of the body carried on a long spine. The length and shape of the tail and the number of fins vary widely between the species.

ANIMALS

Sketches enable you to explore behaviour and characteristics – an expression, an attitude or an action – and to discover suitable drawing media. For example, a simple line drawing can convey movement, a conté or a pastel may already give a sense of the texture you want to draw. Use the medium to help you in your drawing, and let the paper represent tone and colour.

Making a drawing that sets an animal in its own environment, whether it is a cat sunning itself in the garden or cows in a field will tell the viewer more about the animal.

Quick sketches

Draw the animal in as many different poses as you possibly can — catching it asleep or eating are particularly good times — making a number of small studies on a page of your

sketchbook. If the animal moves, abandon the drawing for the time being and go back to it when it resumes the same position. Use pencil or conté; make the outline suggest texture.

Emphasizing mood in the composition

Character can be enhanced by the mood of the drawing. As an example, this sleepy cat was drawn in soft pencil in tonal masses; these suggest the form of the cat without actually

outlining it. Notice how the contrast between the black cat and the highly lit stone pillar is central to the composition. Note too how this group is framed by the shadows.

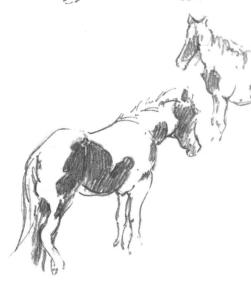

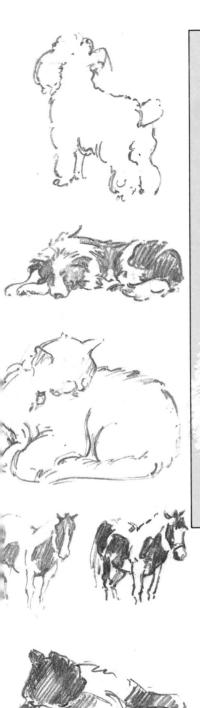

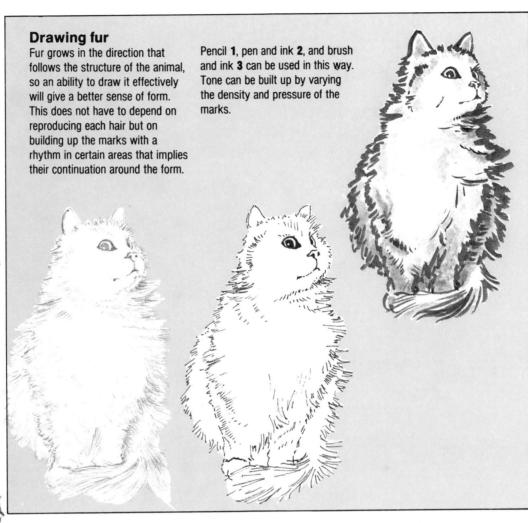

Composing a picture

Introduce other elements into your drawing that will say something more about the animal. The relation of a cat to its owner can make a good composition. Although the cat is not central to the composition it is the focus of it. The girl in this drawing is looking straight ahead but her attention is directed towards her cat and the drawing is very much of the two of them.

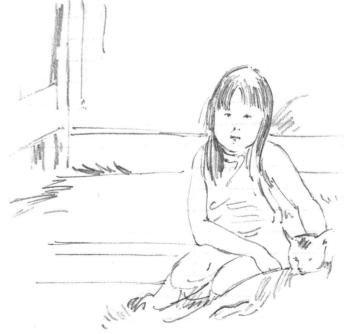

WORKING OUTDOORS

For successful drawing on the spot, first minimize your materials so that they are well organized and portable. Almost everything you tackle out-of-doors will be in motion – people, foliage, clouds. This means working under pressure, and all your equipment must be functional and close at hand.

Decide what sort of landscape to draw. Jot down places you think will make interesting pictures; it is not necessarily the most spectacular views that make the best drawings.

Knives

1 A craft knife with interchangeable blades will trim card, cut mounts and composition board. 2 A scalpel and 3, an X-acto knife cut paper and card. All these knives should be handled with respect.

Setting up A light drawing board can be put up on a metal or wooden sketching easel, or held vertically in the lap, although this position will become increasingly tiring and uncomfortable over long periods. Masking tape or bulldog clips are most convenient for outside use: drawing pins are much too easily lost. You will find that you need a brush holder to protect sable brushes when carried in the sketching bag: make one from a length of cardboard tubing or corrugated paper. Drawing books should

be at least 15 × 25cm; anything smaller will be much too restrictive for making worthwhile sketches. For tonal drawings and sketches, such as those by Turner, washes in gradated ink dilutions or watercolour can be mixed up before going out and carried in separate watertight bottles. Glycerine or a drop or two of liquid detergent in your container of clear water will prevent it from freezing in severely cold weather. You will also need to carry water for cleaning your brushes, for washing your hands and for quenching your

The most practical media for working outdoors are pencil, or pen and ink and brush for areas of tone laid down with diluted ink or watercolour.

A canvas sketching bag with a shoulder strap should be capacious

enough to carry most of the equipment you require, including your drawing board; this will still leave your hands free.

You will find that an easy-to-erect metal sketching easel is quite indispensable for large drawings.

Sharpening a knife

First oil the carborundum stone, then sweep the knife back and forth in long strokes, forefinger on the blade, until sharp.

Other equipment

Distilled water for diluting ink.
Buy this in bulk and decant it.
Gummed strip used in stretching paper. Fixative comes in an aerosol can or as a liquid blown through a Spray diffuser (nickel-plated brass with a plastic mouthpiece) for fixing charcoal, pencil and conté drawings. Putty eraser moulded to a fine point picks out highlights in charcoal.
Blotting paper for ink spills.
Kitchen paper or J-cloths for

every other spillage. Porcelain saucers, in all shapes and sizes, for mixing colours, (Alternatively, an enamel plate.) Plastic palettes are light to carry. Plastic water bottle with separate unbreakable containers. Golf umbrella, and brimmed hat or sun visor for rain or glaring sun; woolly hat and fingerless gloves for the cold. String and a plastic bag, to be filled with stones, for weighing down easel.

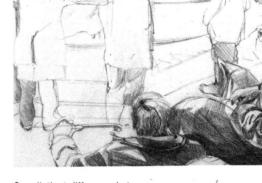

One distinct difference between drawing at home and working outside in the street or at a café table, for instance, is that you are bound to attract an audience. It may be just an inquisitive child but you will probably have to learn to resist conversation as well as endure the scrutiny and curiosity of passers-by.

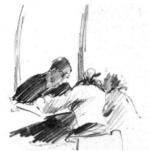

Take time selecting your subject and walk around looking from different viewpoints, varying the amount of distance that you take into the subject. Start by choosing a subject with fairly shallow space, such as a garden that is bounded by a fence, or close in on the main point of interest, such as the barn shown here. Restrict the number of elements in your first composition.

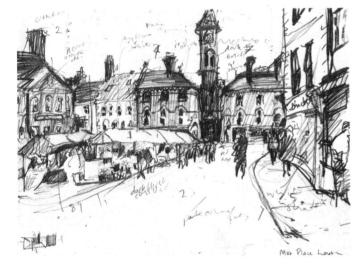

Selecting the subject

It is helpful to isolate a part of the landscape by looking through a viewfinder (which can be made by cutting a window from a piece of card). Restricting your view of the landscape stops your eye from taking in too much and clarifies the composition. Pick on some strong lines, such as a tree in the foreground or the horizon.

Moving away from the focal interest of the composition, notice how the extra depth of field pushes the barn into a deeper middle distance — it is still the centre of your drawing, but there is more space around it; this must be organized. Indicate bands of different tones to lead the eye into the composition. Here a shadow emphasizes the foreground, with the sky as the background.

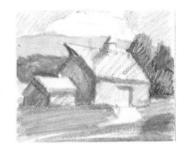

Drawing in the landscape

Unforeseen hazards such as marauding insects or animals in the country and obstructive traffic in the town are often unavoidable. However, do not run the risk of neglecting your personal comfort as this will make it difficult to concentrate. Fishing tackle shops are a fertile source for items such as large umbrellas which afford generous protection from the weather, folding canvas chairs (and even lead weights for making plumb lines).

The far horizons are distracting when working outside and many hours can be spent pleasurably, but not very profitably, wandering about searching for an appropriate or pleasing view. Isolate an area by cupping your hands or using a rectangular cardboard viewfinder (above). Drawing in direct sun, the glare reflecting off the white paper, can be most uncomfortable; take advantage of the shade of a tree if at all possible. In bad weather get under cover in a barn or doorway.

When you move to a far view, the object is no longer dominant enough to anchor the composition. Instead, set up a horizon, or clear middle division: on this the barn will now sit. Behind and in front of the line place other objects — the tree on the left sets up a diagonal with the barn and this invisible line is echoed in the foreground shadows. A bush defines the very front plane.

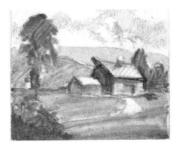

LANDSCAPE DRAWING

Drawing landscape provides a complex challenge – you will be dealing with still life, flowers, people, animals, sky, trees, sea and buildings. And each landscape not only has its own characteristics, as diverse as lush green forests and dry waste lands, but it also changes every minute, with the season, with the time of day and the weather, each producing a different effect on the viewer. So the problem is one of being able to select, of drawing from the landscape the quality that interests you most, to intensify that feeling and to put it down on paper.

Establishing distance

An awareness of the difference in visual impact made by a change of viewpoint is the first step to understanding the problems of setting a landscape convincingly in space. There are some simple devices that will help you. You will see from the landscapes opposite that objects or landmarks become smaller and higher up on the picture

plane as they recede. And with distance also become less distinct, with changed colours. Making a simplified tonal arrangement of foreground, middle- and background will help you isolate the separate planes before you put in any detail so that objects that appear to be tonally similar remain in their own plane.

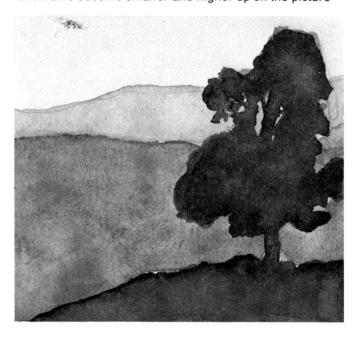

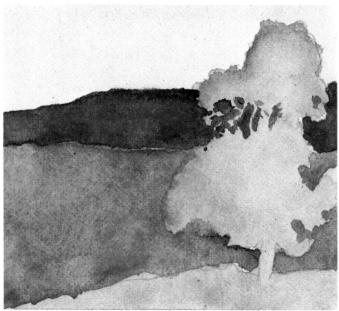

Work either from a dark foreground to a light background or from a light foreground to a dark background, thus creating layers of space rising up the paper. Define the edge of each plane with pencil or charcoal and shade in the tones, or, as here, brush on three graded dilutions of sepia ink for the fore-, middle- and background.

The purpose of this exercise is to simplify the planes, to put each element firmly into its own space, so do not add any detail at this stage. Concentrate on the power of the silhouettes and be aware of the suggestion of space that can be made by a firm over-lapping of shapes on one another in the basic structure.

Setting up

A main consideration when drawing outside is the elements, so make sure that you are dressed for the weather – a sun hat for bright days and warm clothes for cold days (you will probably be standing or sitting still for several hours at a time). The lightest

breeze will lift your paper from the board so it is important to pin or stick it down securely. Take enough materials to last you through the day, particularly plenty of paper. A pad of newsprint or other cheap paper should be used for a series of preliminary sketches, which will help

you to loosen up before developing a finished drawing. Charcoal is a good medium to use to begin with as tonal areas can be blocked in quickly, but since colour is one of the most exciting things about the landscape you may also want to take a variety of colour media.

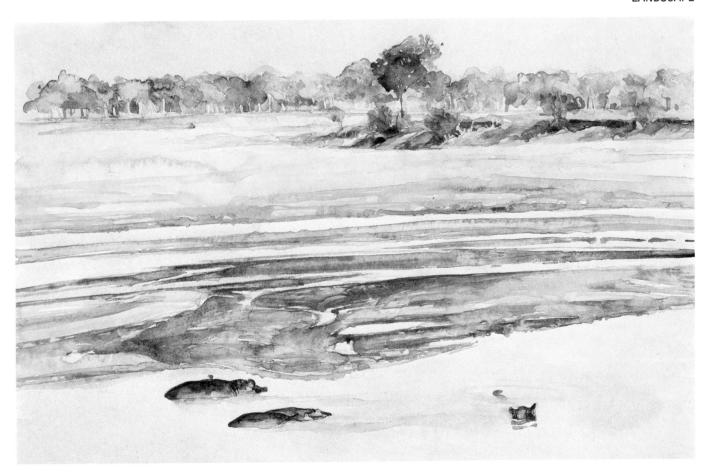

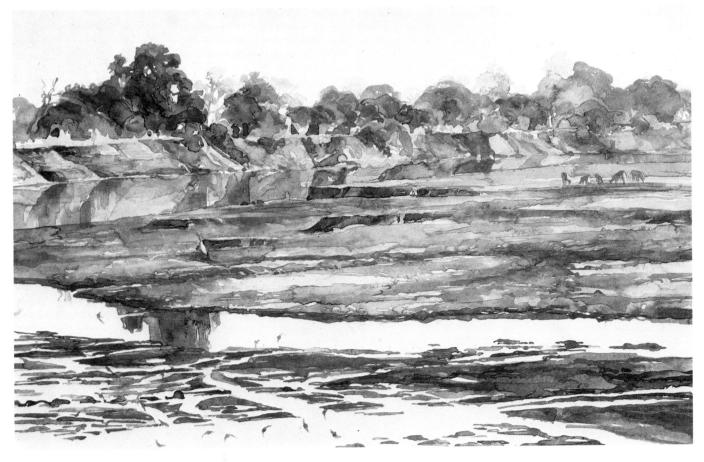

COMPOSING THE PICTURE

Once you have chosen your landscape you will need to make preliminary sketches to practice your technique and to decide on the viewpoint of your final drawing. As you refine the composition it will change in character – some areas becoming accentuated others being eliminated altogether.

The quality of the light can have a dramatic effect on the mood of your work; even light imparting quite a different feeling from dappled or strong, directed light.

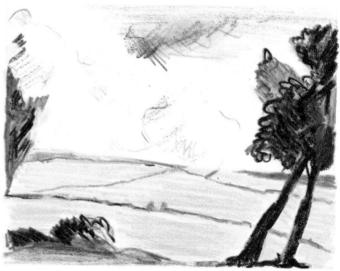

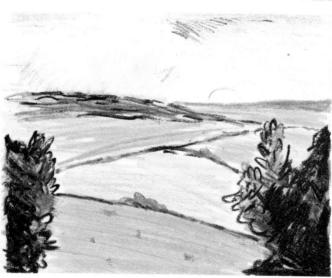

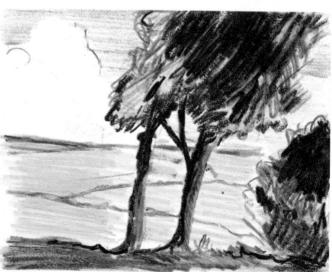

Having chosen a landscape, make quick sketches to see how the composition looks on paper and also to practise your technique. You will soon see the difference in the emotional effect of a drawing that even a slight change of viewpoint can produce. As in these quick crayon sketches start with the horizon, then lightly draw in the shapes of the

foreground, and especially those which stand out against the sky: these are the most important ones. Will you use them to frame or to be the centrepiece of the composition? As you experiment, try to depend less on outline and compose in tone and colour masses. These sketches lay the groundwork for your final drawing.

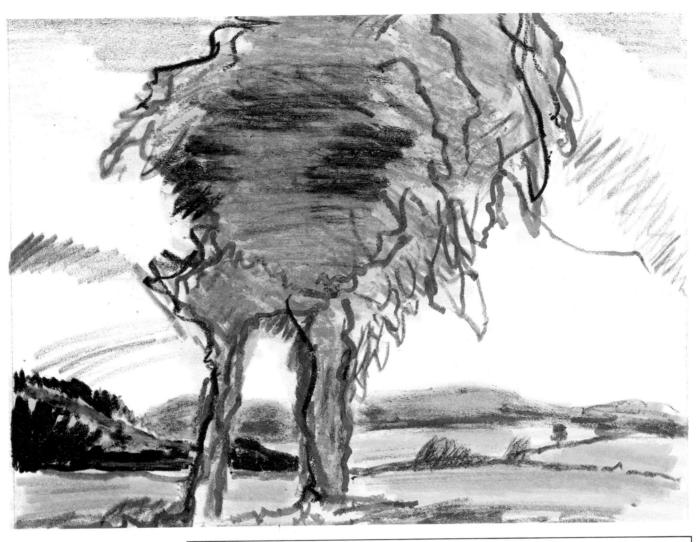

Developing the drawing

This drawing develops sketch **4.**As you refine the composition its character will inevitably change — parts will be accentuated, rearranged or lost. Note here the alternation of lights and darks on the field behind and the importance of negative shapes.

Composing with light and shadows

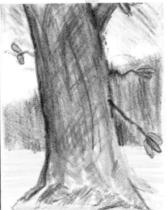

In even light the shape of the tree is clear, the colours are true, the space is uncomplicated. The drawing is simply organized and the light has flattened out the planes. The effect is undramatic, quiet; subtle, even wistful.

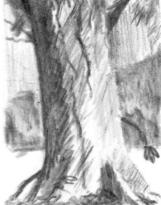

A strong, directed, harsh light breaks up the form of the tree into dramatic shadows and colours. It stands out in relief against a background in high contrast of lights and darks. The diagonal cast shadows dictate the composition.

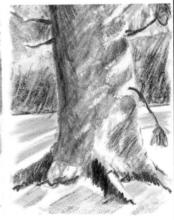

Dappled light is thrown by the leaves of this and other trees and creates a mellow or even nostalgic mood. The light fragments the form into abstract shapes of light and shade, and the drawing can easily lose coherence.

SKY AND WATER

The sky determines the mood of the landscape and changes its colours, so it is important to make detailed studies of it. Think of clouds as mass and treat them not as flat outlines but as three-dimensional forms, with their own areas of light and shade, that cast shadows on the landscape. Do rapid sketches to capture fleeting effects and use these studies to build up a knowledge of characteristic conditions.

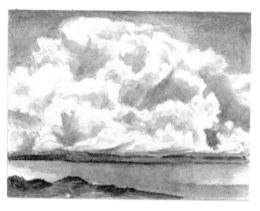

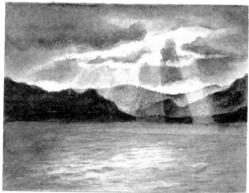

four different relationships of clouds and sky to water and land. 1 The cumulus cloud massed in sculptural shapes stands over a low horizon in contrast to the flat land. 2 Shafts of light burst through the cloud, leading the eye down to the water. 3 An unusual formation of clouds makes the architecture below seem more solid. 4 The surface of the river mirrors the shapes of the clouds.

Every part of the world has its distinctive cloud formations, just as each has its distinctive landscapes. These watercolour studies show

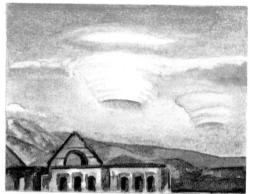

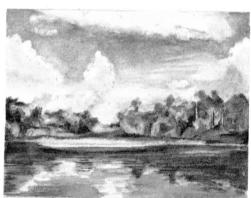

Colour and time of day

Notice the change in shape and colour that happens to clouds throughout the day. These oil pastel sketches contrast the clouds lit by the midday sun from above with those at sunset, when they are lit from below. A bright blue midday sky has subtle colour variations that should be observed. It might be a pinky blue near the horizon, becoming more purple higher up.

Water

You should make studies in different ways of drawing water, too, since it is almost as changeable as the clouds and needs practice to be drawn with conviction. The surface of water varies not only with the weather but also with its surroundings, and reflections can play an important role in the colour and the composition of a drawing. Water is always in movement, and this must show in the patterns of its surface, whether matt or reflecting.

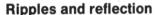

As water recedes you will see less of the dark, transparent surface and more of the reflection of the sky, caused by the changing level at which the angles created by the waves or ripples are seen. If you simplify these shapes into rounded patterns to suggest liquid form the water surface will recede back to the horizon.

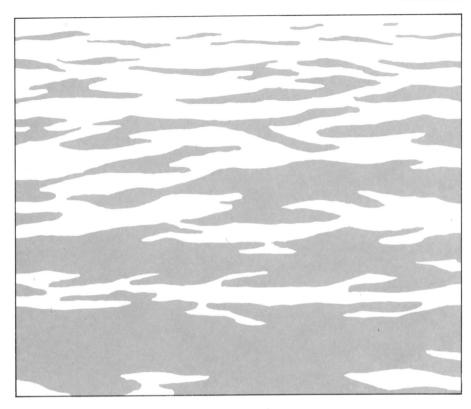

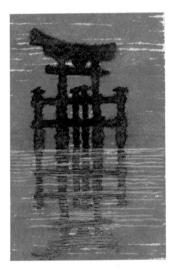

Water movement

1 Slight movement can be indicated by a horizontal division in the reflection. 2 The image is broken into distorted, rounded shapes by rippled water. 3 In rough water the image is fragmented to such an extent that only colours are seen.

Problem areas

The meeting of water and land often causes difficulty. Reflections are one means of leading the eye across the break. When there are none, try including elements that lead out into the water.

The recession of a river back into the landscape is often particularly difficult. To avoid letting the river mount up the sheet, work out the plane along which it runs, and then indicate curves within these limits.

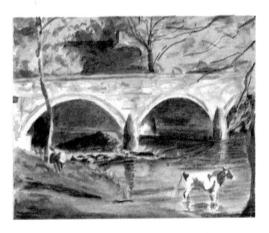

TREES

Trees make a fascinating study in themselves. Draw them at different times of the year and watch the change from the skeletal winter outline through to the abundant green masses of summer foliage.

An understanding of the basic structure, approached with a study of botanical details in the same way that you might study the anatomy of the human figure, will help you to understand their growth and so enable you to draw with ease the characteristic quality of a particular species in relation to the landscape.

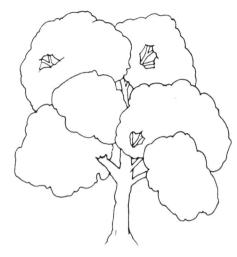

Understanding the structure

Before you start to draw a tree first look at its overall shape. Notice the proportions of the trunk, and than half close your eyes to see patterns made by the foliage, noting in particular the shapes left between the leaves. These glimpses of sky behind add interest and increase the feeling of the tree as a massive free-standing form in the landscape.

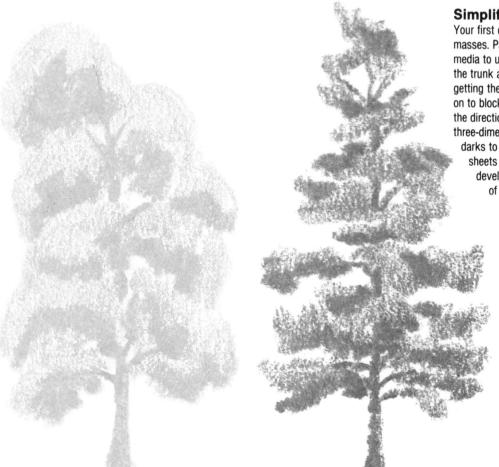

Simplifying the form

Your first drawing should explore the main masses. Pastel, used here, or charcoal are good media to use for a bold approach. First plot in the trunk and main branches — the skeleton — getting the proportions right before you move on to block in the clumps of foliage, feeling for the direction of growth. Add a suggestion of three-dimensionality by building up lights and darks to suggest the fall of light. Use large sheets of paper for these drawings and develop the study to explore the contrast of the shapes of different species growing close together.

Collect acorns, pine cones, unusual fruits or leaves to take home and make detailed studies in various media. See how the texture is differently expressed in the crayon drawing of the pine cone and that of the acorn, done in fibre-tip pen.

79

Varying the medium

Some precision is possible with pencil; it can also be used to suggest atmosphere, and flickering light.

With wash, mark in the trunk, dark, then build up the clumps of foliage.

Pen and ink demands a more exact articulation of each branch. Shape the trunk, then follow out the branches, analysing them into leafy clusters.

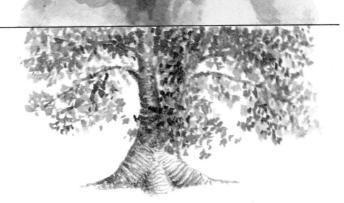

Studying the details: leaves, twigs and fruits

Having got to grips with the basic structure, you can explore the detail. Take a sprig of leaves and draw the outline in pencil, noticing the arrangement of the veins and how the leaves are attached to the twig. Now go on to refine the details in pen and ink.

been modelled in pen and sepia ink in tight cross-hatching, and a green wash was then knowledge of the subject, but are attractive

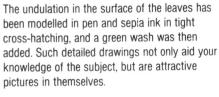

SEASCAPE

The sea is a challenging and exciting subject to draw. Its colour, reflections, shape and mood are always changing, in turn affecting its compositional relationship to the land. Watercolour is a natural medium for this subject. Use it to evoke an impression of colour and mass and the swell of the waves.

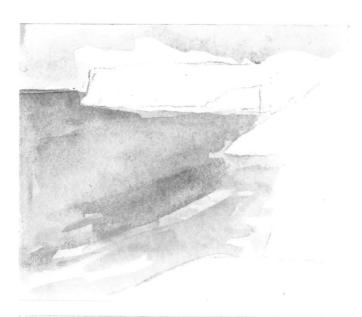

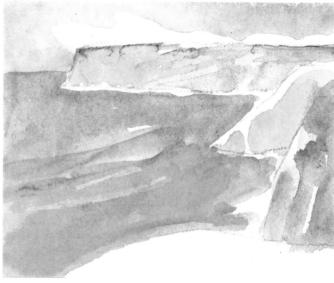

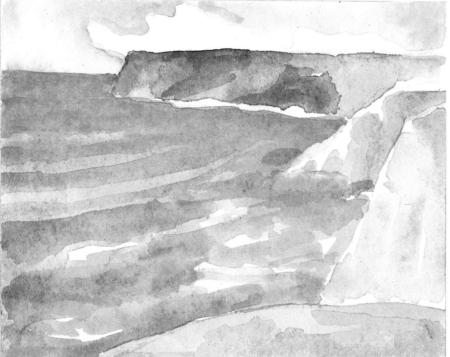

If you have planned a long drawing session sit above high-tide level! Select a composition and sketch in the main shapes in pencil, starting with the horizon. The first wash should be the blue around the clouds. The white paper can be left to represent clouds and the froth of waves.

Mark in the land and then start on the layers of water, dividing it up into light and dark as it gets deeper and as the waves give way to swell. Now work (left) on the tonal relationship between the water and land, remembering that every new layer of wash will increasingly darken the picture.

As far as the balance of colour goes, the drawing is finished. Additional touches to the water or sky will only darken them — possibly with disastrous results. However, having allowed the washes to dry, you could refine some areas of the sea by adding Naples yellow or a light purple. If you want to add grey to the clouds use a dry wash to make sure that the colour does not spread. When adding detail to the land take care not to let the edges blur.

You can make final refinements with pastel, including any alterations in the balance of colours and of dark to light. A few crumbly pastel strokes will liven up light-reflecting forms such as the foreground rock, or a blue will add depth to the darker water at the horizon. Alterations to the sky can also be made in pastel. A few slight touches of colour here and there help to give an effect of movement, so that the clouds seem to scud in the wind. Resist the temptation of overworking the drawing and keep it looking fresh.

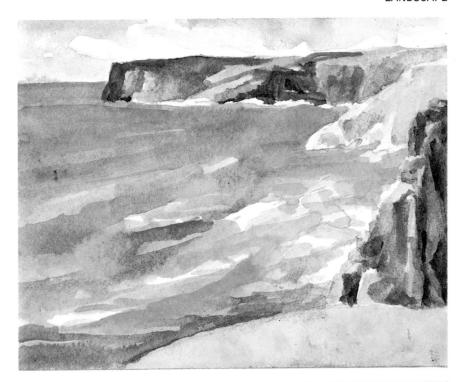

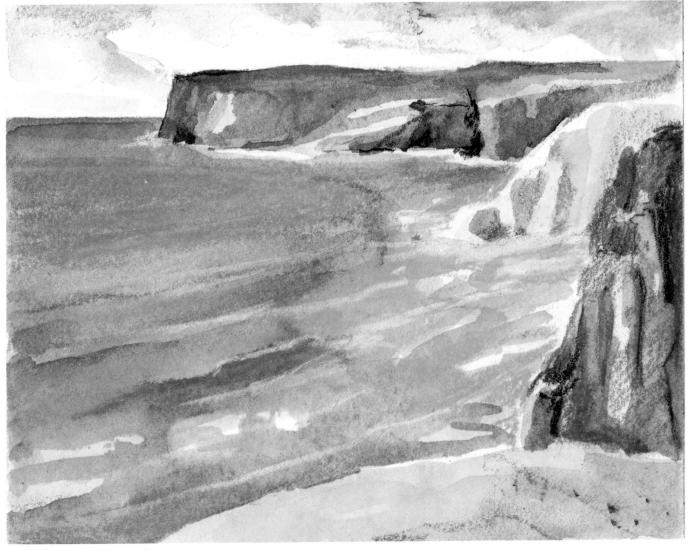

SKETCHBOOK DRAWINGS

Sketch as often as you can. If you can carry a pocket-sized hardback book with you wherever you go you will not miss an opportunity to sketch something that catches your eye, and you will build up a visual diary which can be fascinating to look back on. You will gain valuable drawing practice, and also learn to be constantly on the look-out for subjects. These studies and impressions are working drawings, not finished pictures. Use them as reference material in the same way as you might collect magazine cuttings and photographs.

Natural objects and flowers

Make exploratory drawings of flowers, shells and stones to record details, building up from simplified contour lines without

erasing any lines. Fill the page with studies of different parts of the flower seen at different angles. It is interesting to make a study of a

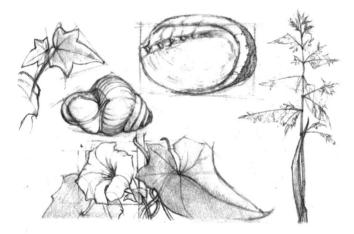

Figures

People become very self-conscious when they know they are being sketched, so if you want your 'models' to pose naturally you will have to be inconspicuous. If you are using a small sketchbook at some distance, they propably will not notice. A larger sketchbook will be more suited to figure drawing but will soon be spotted, so sit somewhere out of view and pretend to be sketching something behind the subject, or to one side. Draw people reading, asleep or watching television for longer studies. Do some quick line sketches of people in action to capture movement.

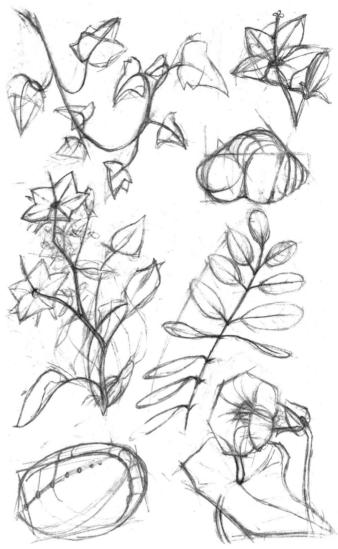

plant over a period of several days to see how it grows — remember to date your drawings. Find out the names of the plants you draw and label them; if they are rare make notes of their colour on the

drawing. If they are not, pick one and press it. Bring home shells and stones or almost any other interesting natural objects you find in order to study them in detail at your leisure.

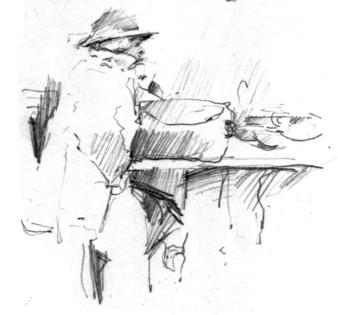

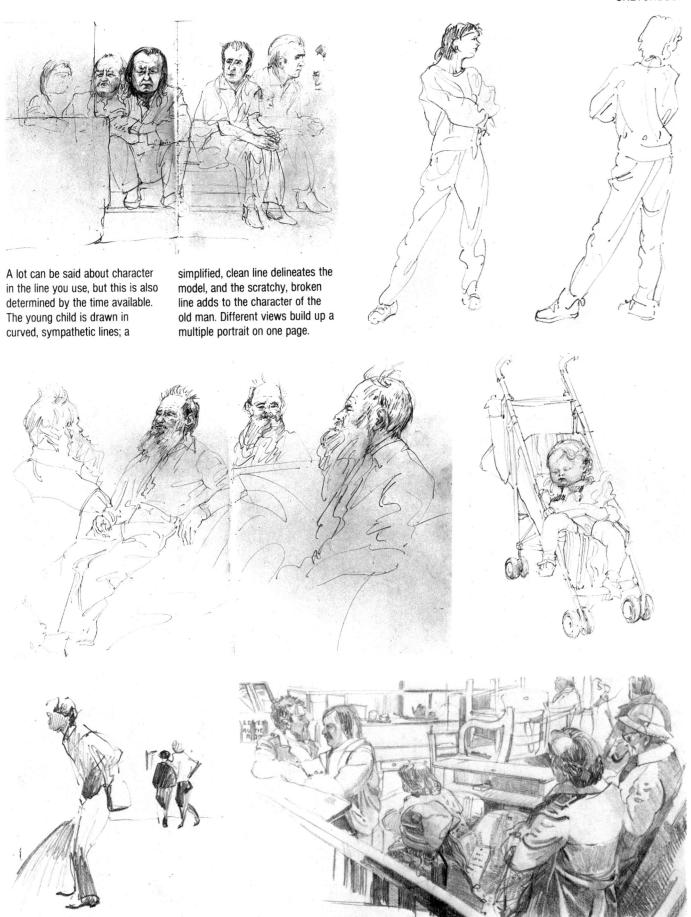

Sketching the countryside

The limits of the paper should not restrict your drawing. If the subject is a wide panoramic view use the double page of a sketchbook, and stick extra sheets on the side if you want to continue it. Find a place you want to draw and make several drawings of different views. If you can spend a whole day in one place try to capture the changing light by making drawings of the same view at different times of day. Return to the scene at a different time of year and see how it has changed.

You will have to be selective – focus on a particular scene that interests you, or

concentrate on one aspect, such as light and dark, or the shapes of trees or cloud studies. A

wide scene can tend to break up into a series of small scenes — make sure it has cohesion.

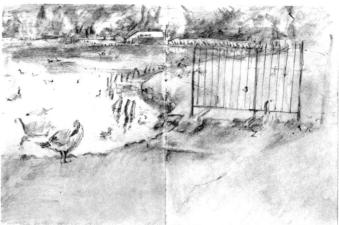

Pencil sketches

Make linear and tonal pencil sketches, picking out what attracts you about the scene and just indicating areas you are not interested in. Sketch in the main areas to establish a framework on which to add the detail. Superimpose drawings of nearer objects on top of things that are further back. If you stay still birds will get used to your presence and will come closer to you. Cows will be inquisitive at first, but will ignore you after a time. Try to settle into the slow rhythms of the countryside to find its real character.

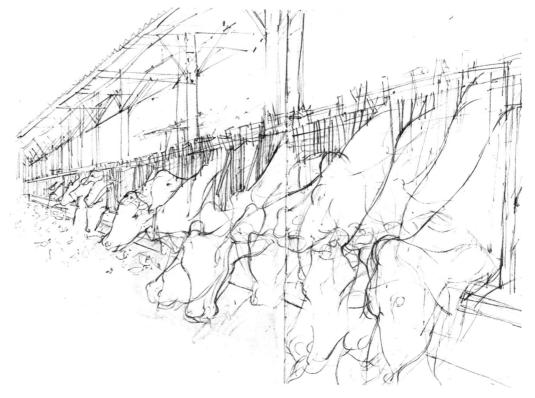

Sketching in the town The town provides a wealth of

The town provides a wealth of fascinating subjects for which you will need a certain amount of perseverance since you will not be left alone to your drawing; try to find a secluded viewpoint.

Railway stations can make unexpectedly evocative drawings. These dense, high-contrast studies made in soft pencil give a good impression of the grimy, smoky atmosphere. The architecture is given a monumental quality through this treatment.

Buildings generally demand a linear treatment which is more successful for the finer details but use your sketchbook to try out as many different materials and techniques as you can.

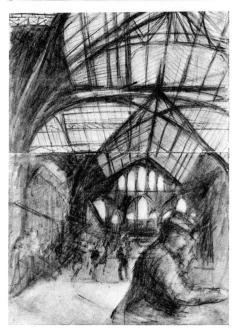

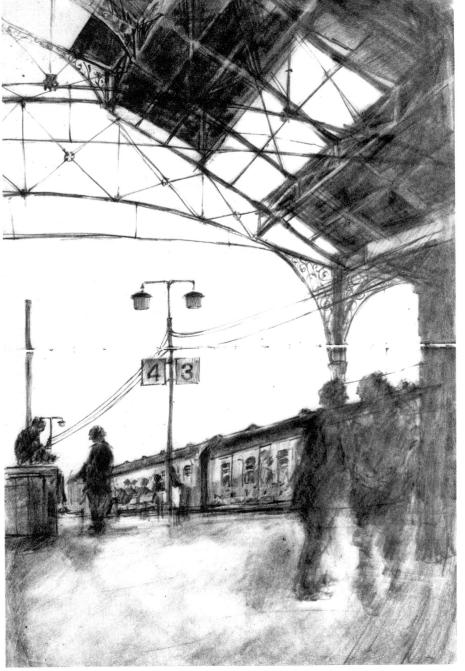

PERSPECTIVE

Suggestion of spatial recession can be conveyed in most landscapes by drawing from observation or by using one of the devices mentioned on page 71. Greater accuracy is important when drawing a subject such as a row of trees or a building; then you will need a grasp of the basic principles of perspective. This is a system based on the observation that parallel lines converge over distance towards a vanishing point on the horizon and all objects diminish on the same scale as they recede.

Simple methods of understanding perspective

Converging lines (orthogonals) can be understood better if seen through a viewfinder (see p71). The frame will isolate the angles they make and will plot them on a small scale against a true horizontal and vertical.

To force yourself to draw angles that the eye is unwilling to accept and that you have difficulty in estimating, trace the image with a chinagraph crayon on to a piece of Perspex held securely up against a window.

Curves in perspective

Straight-edged objects remain straight-edged in perspective, although their angles might change, but when curved objects are foreshortened the nature of their curves is altered. Circles become ellipses, which vary in depth the further they are from the eye.

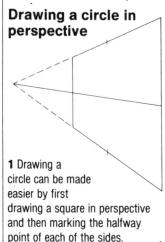

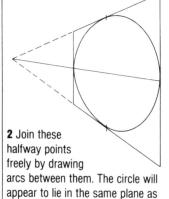

the rectangle.

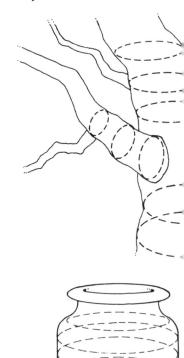

Eye level

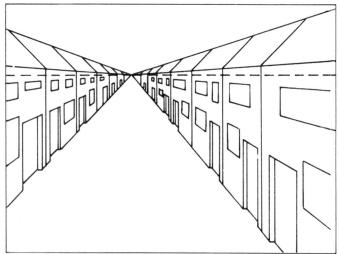

The eye level of the viewer determines the horizon line and the angle at which the converging lines recede until they meet at a vanishing point on the horizon. When drawing from a high viewpoint (as here) you will naturally tend to give the drawing a high horizon.

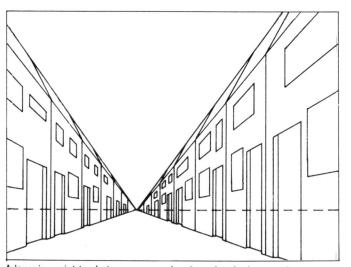

A low viewpoint tends to encourage drawing a low horizon on the paper. Notice how a different view of the subject changes the composition and how it creates a different mood. Remember that all receding lines above the eye level slant down towards it, and all lines below slant up to it.

Analysing cylindrical forms in perspective

Tree trunks and branches as well as other cylindrical forms can be thought of as a series of encircling contour lines which

become less or more shallow depending on the distance from eye level. Preliminary drawings done in this way help an understanding of volume.

Edges in rounded objects

When drawing cylindrical objects, such as jugs or vases, note that the elliptical curves become deeper the further down from the eye level they are. This determines the shape of the base — a fluent curve without an angle.

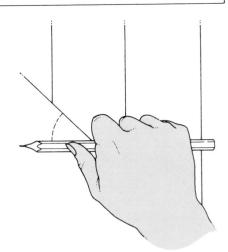

Judging angles by eye

Geometric perspective can be used to make all the angles of receding lines consistent. The first angle, however, must be judged by eye. It can be read against an existing vertical or by holding out a pencil at arm's length.

Constructing a drawing in perspective

Explore the methods of constructing an accurate drawing by making a study of a simple subject such as an empty hallway and then introduce objects into it to develop this study. You will soon realize that you first have to be able to judge the angles of converging lines by eye before using the eye level and vanishing points to determine other lines. The vanishing point can be a visible point on the horizon, as illustrated in the street scene opposite. It is, however, more often a purely notional point which the receding lines would meet only if they were continued, and this very often extends past the limits of the paper.

One-point perspective

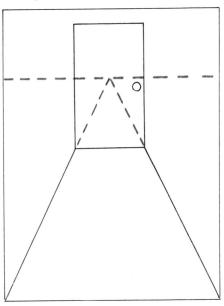

- 1 Draw in the verticals and then the horizontals seen straight on (these remain constant). Now draw in the receding lines and continue them until they meet a point on the eye level.
- 2 Draw in other objects that are parallel with the door (ie with the picture plane) or with the wall. Notice how all the converging lines recede to the same point.

Move the table at an angle into a different plane. You will observe that it now has two sets of converging lines and two vanishing points on the same eye level. Vertical lines remain constant.

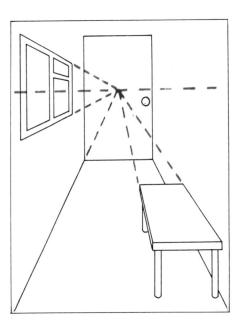

Two-point perspective

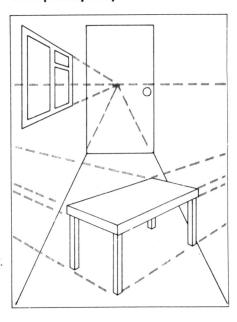

DRAWING BUILDINGS

Townscapes demand a knowledge of perspective, and are natural subjects on which to practice it. Perspective, however, should not be the only ingredient of your drawing – tonal and textural variations are needed to give real conviction to the web of neat lines. The usual way to proceed, is to introduce light and shade over a grid of perspective lines. The lines generally are left intact, but with a medium such as crayon or pastel you can dissolve the edges and seek dramatic effects, even though you retain an invisible perspective structure beneath.

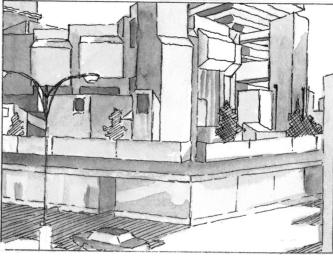

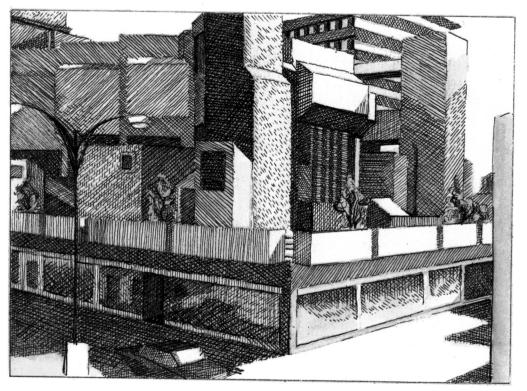

Begin with a simple sketch, using line to identify the main angles. Remember that vertical edges remain so in the drawing, it is only the other angles that change. With the verticals established, plot in the directions of the main features — the roofs and bases of the buildings.

Over the simple perspective sketch, add the main shadow areas and pick out significant details. Here, wash has been used for the main shadows with pen and ink hatching on top. In the finished drawing, elaborate tones have been established, accurately defining the complex architecture.

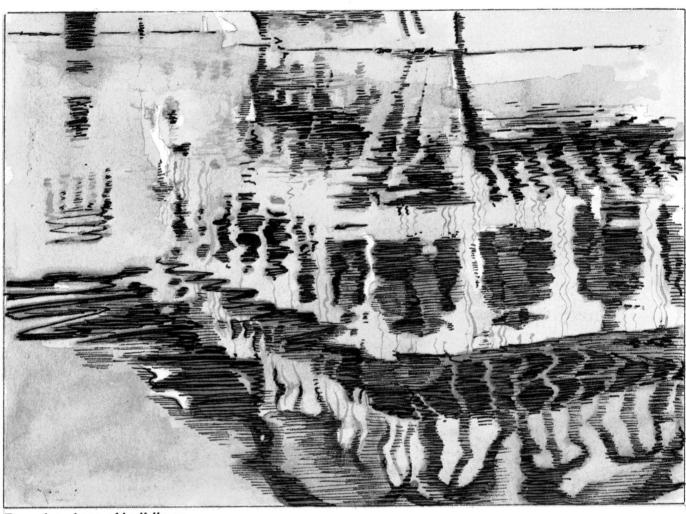

Free drawings of buildings

Buildings need not always be drawn so precisely. Here, by choosing the reflection of a building in water it is seen as a design of patterns and shapes. The drawing was begun with a pale wash, which was then built

shapes. The drawing was begun with a pale wash, which was then built does not outline the shape

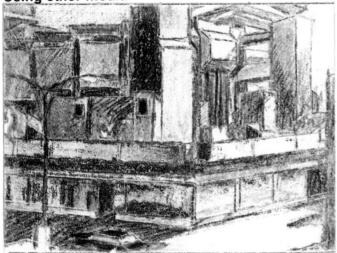

Using **charcoal** and **conté crayon**, together or separately, gives considerable scope for tonal variation and the introduction of texture. Detail, however, is not easily dealt with. In this drawing, the tones were first laid out in charcoal and were subsequently deepened in conté.

up into darker tones. Some tones were enriched with pen, establishing the rhythms running through the groups of broken shapes. The pen does not outline the shapes, but defines them as tones and textures.

Fibre-tip pen has advantages but also limitations. It is a highly fluent medium, good for sketching out the bones of the scene quickly. But it has almost no tonal variation and, without carefully planned hatching, it may merge into a solid mass of black with no middle or light tones.

ARCHITECTURAL DETAILS

Buildings are often rich with details that give individual character and make them interesting subjects to draw. The regular repetition of architectural mouldings may need to be shown. Avoid undue elaboration – learn to suggest details with a few strokes indicating a firmly grasped structure.

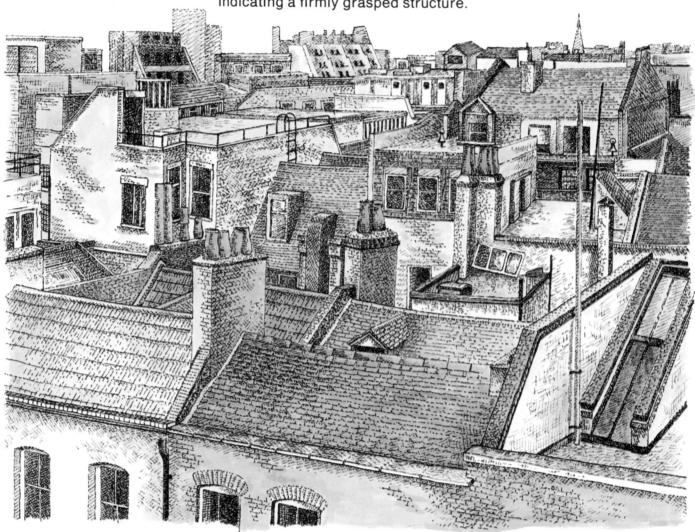

A roof study

When drawing complex and detailed groups of buildings, first find the underlying structure of the composition. Here, the view is divided into thirds by the main verticals, while the perspective converges in two opposite directions, giving rise to quite complex problems.

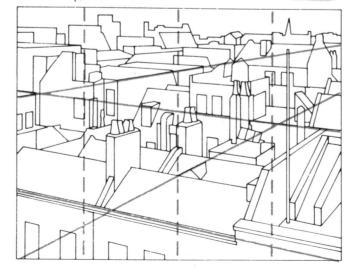

Texture in buildings

Although you must start with the main shape of the building, draw textures as you progress rather than leaving them for the end. Having outlined the pattern of these tiles (right), for example, the differing textures could be developed and contrasted with the foliage of the tree.

Curves - bridges and arches

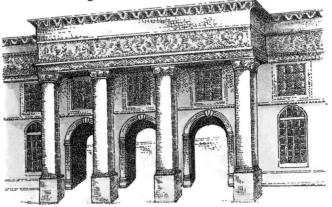

Because the portico (above) is set at a slight angle, the curves of the arches are not quite true. Even more important, they are smaller as they are farther away, and consequently less of the background is visible through each of the arches. The perspective of a bridge (below) is complicated by its rise towards the centre and the elliptical curves of the receding arches. Draw in the main lines of the perspective; add the arches as freely drawn curves. Then develop the reflections and light and shade on the bridge.

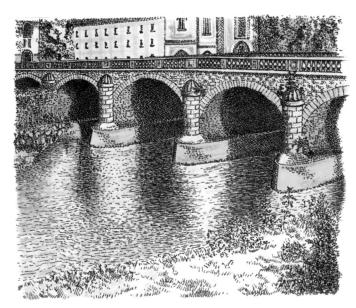

Stairs

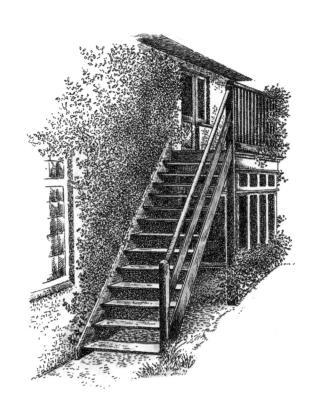

Both of these studies of stairs were done by sketching in the basic geometric shape — a cube and a cylinder — in which each form is enclosed. The main lines of the straight stair, converging to a single vanishing point, came first to form a rectangular box. The addition of diagonals gave the line

of the stair and the banister. In the same way, a drum was drawn for the curved stair and the outer and inner rails were then added. In both cases, the steps themselves came last. Notice how less of each step becomes visible as the stair rises towards and above the eye level of the drawing.

COMPOSING FROM SKETCHES

It is not possible to draw constantly changing scenes from life. Make studies of the essential forms and telling details; then develop them into a composite view, making adjustments to suit the final design. Keep a sense of place, however; do not neglect the setting when making your preliminary sketches.

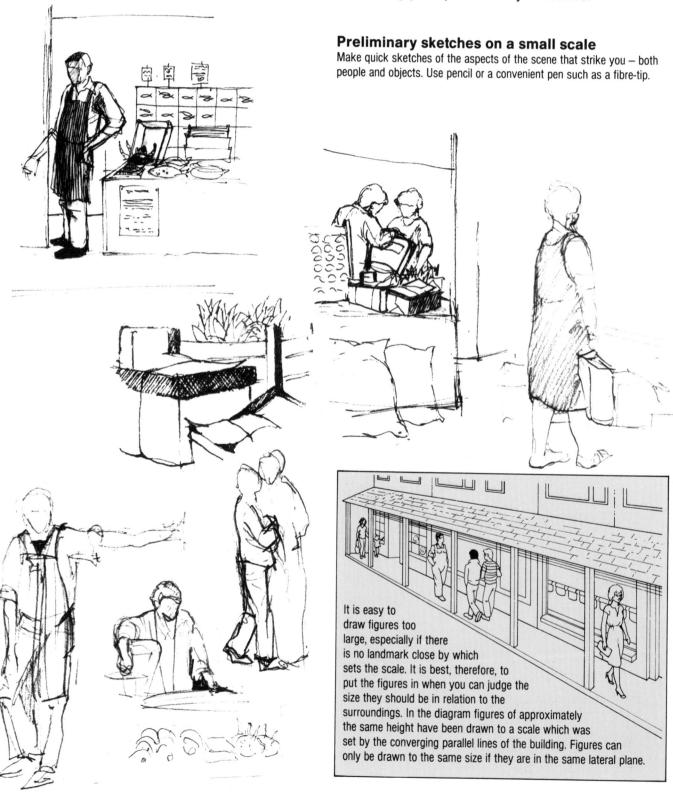

COMPOSING FROM SKETCHES

When you have settled on a composition (below), include all the elements of the final drawing. Here, a toned Ingres paper has been chosen, with the lighter tones heightened with white conté. Work on the whole drawing, darkening and lightening passages over the whole area of the paper.

The basic composition

The next stage is to use the sketches to construct a composition (above). Start with the underlying design, indicating the perspective and the rough shapes of the people or any other elements you will include. For this it is advisable to use charcoal or crayon to register the distribution of light and dark sensitively. Try various compositions until you find one that fulfils your intentions, moving people and objects until you establish a satisfactory overall arrangement of the shapes.

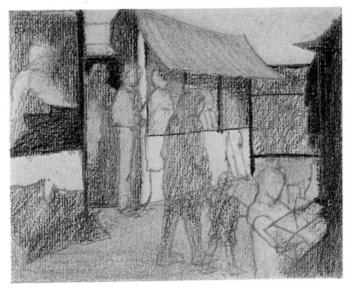

Experimenting with tracing paper

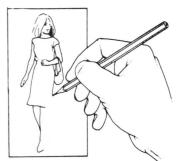

One way of developing a complex composition is to rough out the design and then sketch figures on separate pieces of tracing paper.

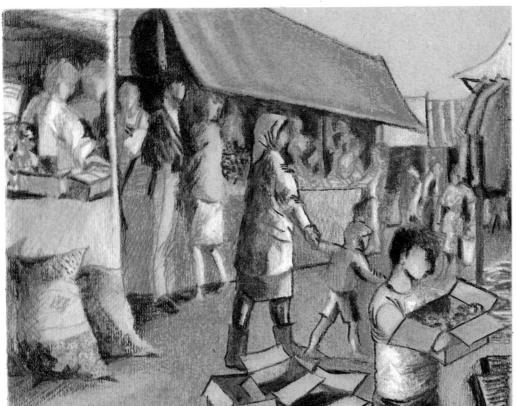

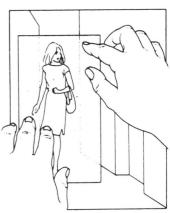

You can then try them in varying positions and adjust as necessary.

DRAWING AIDS

At some time you will want to work on different aspects of your drawings to perfect a particular technique or style. The following pages introduce you to the range of drawing aids currently available and their uses. The various methods for enlarging and reducing a drawing are covered; as are the ways of making tracings and adapting them to your needs; and the advantages of using a mask.

Short cuts and simple tricks can sometimes help to keep the spontaneity of a drawing, though over-use of some aids can give a laboured look and negate that intrinsic lively quality you are seeking.

Pencil and coloured crayons

ENLARGING AND REDUCING

If you want to enlarge a finished drawing to a particular size in preparation for a painting, or if you need to enlarge or reduce an image you have drawn by a given proportion, the methods given here will help you.

Squaring up

By drawing a grid over the drawing and then reproducing that grid at a larger scale the lines and shapes within each square can be plotted by eye in the corresponding square on the larger grid. The size of each square will depend on the size of the picture, but smaller squares will increase accuracy.

Marking out the paper

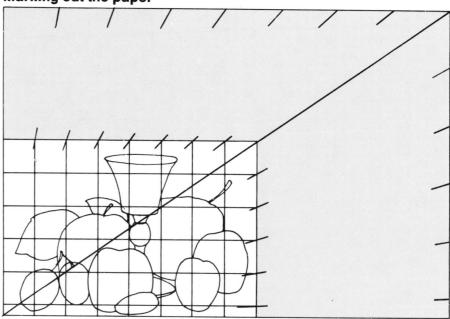

Drawing accurate lines

Use a T square for the horizontal lines and a set square for the vertical ones. Stick the paper down on a drawing board, taping the corners diagonally. This ensures that the paper is

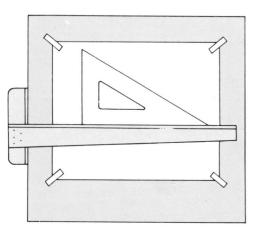

stretched really tight. Make very sure that the pencil point runs against the straight edge — if it is held incorrectly the point may be deflected away from the intended line.

Use a T square and set square to draw an accurate grid over the drawing and then tape it to the bottom left-hand corner of a larger sheet of paper and accurately align the grid again with the T square. Extend the bottom line to the required width of the enlarged drawing and draw a line at right angles to it. Extend the diagonal of the original grid to intersect this vertical line. This marks the height of the enlargement from which you can draw the rectangle. To plot the grid on the enlargement, align a straight-edge ruler to pass through the bottom left-hand corner of the rectangle and the furthest point of each vertical and horizontal line of the grid. Mark where the ruler meets the edge of the larger rectangle and draw a new grid using these points.

Other methods of enlarging and reducing an image

Dividers If you want to enlarge or reduce your drawing by a simple proportion, such as two or three times, you can do this very easily by using a pair of dividers to step off the measurement. Having set the dividers to the length of a line on the original, 'walk' them the required number of steps along a line on a new sheet of paper.

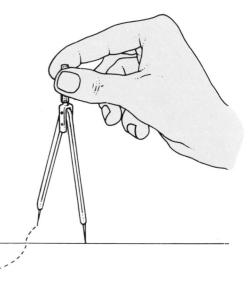

Projector A transparency can be projected on to paper taped to a vertical board. Move the board and focus the lens until the image is the size needed. Plot the major components of the image on to the paper lightly with a pencil, switching off the projector to look at your work.

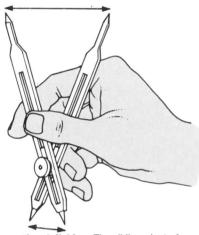

Proportional dividers The sliding pivot of proportional dividers can be adjusted to arrive at a number of set proportions. If set to a proportion of one to three, the distance between the points of the longer legs is exactly three times larger than that between the shorter legs. Measurements can be made with either end — the shorter legs giving enlargement, and the longer legs automatically giving reduction.

Pantograph As the point of a pantograph is guided over the original, the pencil at the end of the arm draws a proportionally larger image. If the point and pencil are interchanged, the image will be reduced. Although a pantograph is easy to use, but will not produce very accurate enlargements.

GUIDES

Stencils come in plastic or thick oiled paper. They will guide the point of a pencil or pen around the outline of shapes — circles, ellipses or letters — which are difficult to draw accurately freehand.

A stencil brush, with short, stiff bristles, can be used to fill in a shape by stippling, or dabbing the brush on the surface of the paper. Excess paint should first be brushed onto scrap paper.

French curves can be used for drawing complex curves when accuracy is required, or when copying a photograph. Having drawn part of the curve, move the guide around to find another part of it that matches up and continues the curve.

Flexible rules are plastic-covered guides which can be used to copy awkward curves from a drawing or photograph. Lay the rule flat on the original and bend it to follow the curve. Transfer to your paper and draw along the bevelled edge.

Drawing large curves and circles

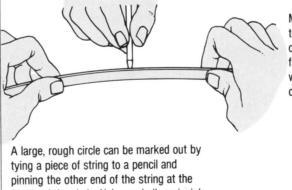

A large, rough circle can be marked out by tying a piece of string to a pencil and pinning the other end of the string at the centre of the circle. Using a similar principle, which produces more accurate results, drive a small nail through a strip of cardboard. Measure the length of the radius required from the nail and punch a small hole, large enough for a pencil point. Swing the card strip around the nail to draw the circle.

Most commercially available templates are small. Rather than cutting out a large one ask a friend to hold a flexible strip of wood to the curve you want and draw along it.

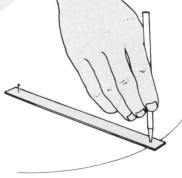

TRACING

Tracing always tends to imply the idea of straight copying. Try to avoid this as it will limit the individuality of your drawing. Instead, use tracing as a means of adapting information from various sources or simply of transferring the bare structure of a sketch or drawing onto a new sheet of paper.

Methods of tracing

Carbon or rouge paper can be sandwiched between the source you are tracing and the sheet of paper you want to use for your drawing. By tracing over the shapes with a used ball-point pen or knitting needle, a line is transferred onto the paper and directly reproduces the image. A carbon line cannot be erased but the fine red powder deposited by the rouge paper can be removed with an ordinary pencil eraser and is suitable for more delicate work. To produce a traced pencil line, make your own image-transfer paper by rubbing soft pencil over one side of a sheet of paper and use in the same way as carbon paper. It is essential that neither the tracing nor the drawing move

while you are working. Having taped both to a drawing board, fold masking tape tabs and attach them to the bottom edge of the tracing

so that you can look at the work from time to time. Do not rest your hand on the drawing or it will smudge.

Graphite

If you cover the back of the drawing or a tracing of it with soft pencil, the graphite will be transferred as you retrace the lines with a pen or knitting needle. But using a separate sheet of paper as described above is less messy.

Daylight

Tape the tracing to a window and cover it with the paper. The strong back lighting will show the design clearly through even thick drawing paper. A 'light box' can also be used in this way. It is a box with a Perspex top, lit from below by fluorescent tubes.

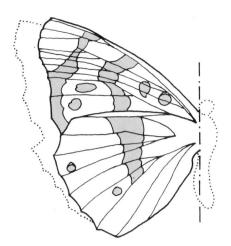

Symmetrical designs

Tracing paper can be used as a short-cut when drawing a symmetrical object. Draw one half of the object and then fold the paper along the central line. Now trace the image again.

Open up the paper to see the complete image and transfer it onto a sheet of paper using one of the methods shown opposite. To produce a symmetrical design reverse and transfer it as a mirror image.

Developing an image

Tracing paper can be used as means of building up a design. It is an excellent method to employ if you are designing your own Christmas card, if you are using a subject that is unfamiliar to you or if you want to take various elements from different sources and adapt them to create a unified image.

1 Decide on the theme of your design and find an image to form the basis. Trace the outline onto a sheet of tracing paper in pencil.

2 Adapt the drawing using new sheets of tracing paper rather than erasing each element so you can re-use the tracings.

3 Trace details from other sources on separate sheets and superimpose them on the design. Trace whole picture on one sheet.

Rubbings

Using the tracing principle of transferring an image through paper, interesting textures can be added to your drawing by rubbing areas with a pencil over wood, canvas, or even a comb.

MASKS

Masks provide the means of defining interesting areas of texture or pattern in a drawing, which would otherwise be a difficult or laborious process. A mask can be made from card, film, wax-coated stencil paper, or found or bought ready made. It will protect areas of paper from ink sprayed onto it, or pencil rubbed over it, to give a sharp edge.

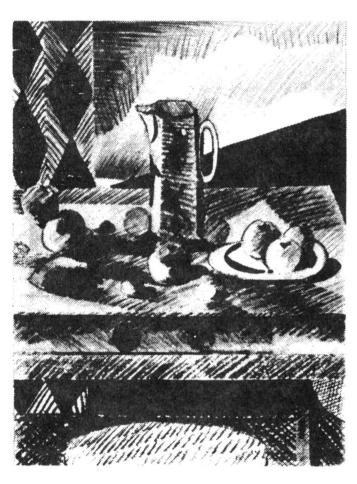

Drawing up to a straight edge

A striking effect can be produced by masking off an edge with a straight piece of paper. Holding the paper firmly down on the surface draw the pencil across the mask in short strokes, always working away from the edge, never towards it. It will leave a crisp edge.

Masking fluid

Areas of paper can be effectively masked out with masking fluid when watercolour wash is being used. 1 Apply with an old brush

and allow to dry thoroughly.

2 Remove by rubbing off with the finger or a putty eraser when the wash is quite dry.

Erasing with a mask

1 A freely drawn texture cannot be stopped abruptly at a definite edge. To achieve this effect mark in lightly the intended edges of the drawing and draw the texture over this line.

Ink or thinned paint can be sprayed using a miniature spray gun or airbrush. An airbrush is expensive and used mostly by commercial illustrators. It will produce flat areas of colour, tonal gradations and can be adjusted to spray fine lines. Where such accuracy is not needed, a small spray gun will give effective results more economically. Both instruments need compressed air; most easily provided by using aerosol cans of propellant. Wash spray often.

2 Lay a piece of sharply edged paper over the drawing to align with the marked edge and use a plastic eraser to remove the part of the drawing outside the line, leaving a crisp frame.

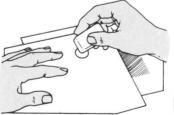

Areas of texture can be taken out of the background by cutting the shape out from a sheet of thin cardboard. Position the cut-out and carefully erase the pencil from the paper within this area.

If the drawing has been made on paper with a hard surface, textures can be scratched into a solid background with the point of a scalpel blade to reveal the colour of the paper below.

A soft edge

To produce a soft edge when spraying tonal areas, hold a piece of card just above the paper. When ink is sprayed across the edge of the card, enough will fall under it to blur the edge of the sprayed area. The degree of softness can be varied by altering the height and angle of the card.

Varying the edges

For an edge that runs from hard to soft, use transparent masking film, partially rubbed down on to the paper, while holding one area of it away from the paper to allow the spray to diffuse the edge. The angle at which you hold the film will determine the smoothness of the transition.

Ready-made masks

Masks do not have to be cut out from card or film. Interesting patterns and textures can be made by spraying over objects that you have collected. Dried flowers, leaves, paper doilies and loose-weave cloths are just a few ideas. You will soon discover a wide variety of masks to use.

A hard edge

A hard, straight edge can be produced when spraying by the method already shown of masking with paper, but it must be weighted or stuck down to prevent it being blown away by the jet of compressed air.

Repeating a pattern

Curved or irregular shapes (above) should be cut from adhesive-backed masking film. Lay a sheet of film over the whole drawing and carefully cut out the shape you want to spray with a scalpel blade. Lift out the cut shape and rub down the rest. The adhesive will not lift ink off the paper, but fix any other medium — pencil, crayon, pastels — before starting.

Straight edges. (left) Stick masking tape firmly along the edge you want to mask. Protect the outer areas with newspaper. Spray and remove tape carefully at once.

A repeated pattern can be built up by moving the mask a little to the side of the first sprayed shape, being careful to wait until the colour is dry. Where sprayed areas overlap, the colour will be stronger and interesting tonal variation will occur. Keep to simple shapes for the mask.

MONOTYPE PRINT MAKING

Monotype printing, a technique revived in popularity by Degas in the nineteenth century, is the simplest and most direct form of print making, which encourages experimentation with a wide variety of materials and techniques. A monotype is produced by printing from an image created in ink or paint on a hard surface by an 'additive' or 'subtractive' method. As the word monotype implies, generally only one print is taken, but many artists will take up to three or four. Results can be unpredictable and you will never get two identical prints, making this a very spontaneous technique. Monotypes can be made simply by hand, or with metal plates, such as aluminium, zinc or copper, printed under greater pressure in a press. Altering the pressure applied will produce a different image.

Equipment

Little basic equipment is required. You will need a smooth, hard, non-porous surface on which to create the image – a sheet of glass or metal is ideal. Good media are oil- or water-based printing inks, but exciting and often

very sensitive results can be achieved from using oil paint, tempera and watercolour. You will need a palette knife and roller or a brush to apply the ink, instruments to incise images, rags with which to draw and clean up, and turpentine for diluting and cleaning oil-based ink.

Subtractive method

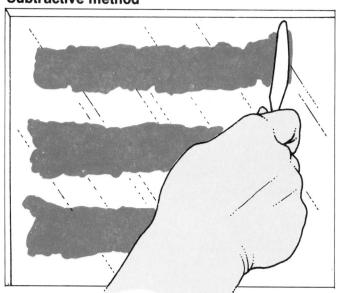

Blue ink will produce a strong image and is a good colour to start with. Squeeze out some ink on one side of the glass and spread it across in bands with a palette knife.

The image is taken out of the ink. A cloth will remove broad areas, or if dabbed on, will create textures.

Drawing with a finger is messy, but will produce smooth, curved lines and traces of fingerprint.

A pencil makes a sharp, thin line. Also try drawing with wooden tools such as the ends of brushes.

Use a lino-printing roller to spread the ink into an even layer over the printing surface. Make sure that the roller is quite clean and smooth. Clean with turpentine or water after use.

Additive method

With this method you will work on the clean surface of the glass, drawing with ink applied by brush. Different colours can be used and the ink can be diluted to any viscosity. When highly thinned it will resemble a watercolour wash. This process can be applied to areas of a plate that have been wiped out when using the subtractive method already described.

Taking a print

Lay a thin sheet of smooth cartridge paper carefully over the printing surface, avoiding any movement once the paper has touched the surface. Apply consistent pressure with the palm of the hand or the back of a spoon, or gently and evenly run a clean roller over the surface. Carefully pull the print up by lifting slowly from the near right-hand corner of the paper.

In this example both the subtractive and additive methods were used. Water-based ink was rolled over the entire surface and large areas wiped out with a cloth, more thoroughly in some areas than others. Texture was drawn into the mid-tone areas and details around the mouth and eyes were drawn with a pencil. Finally, ink was brushed onto the clothes and background.

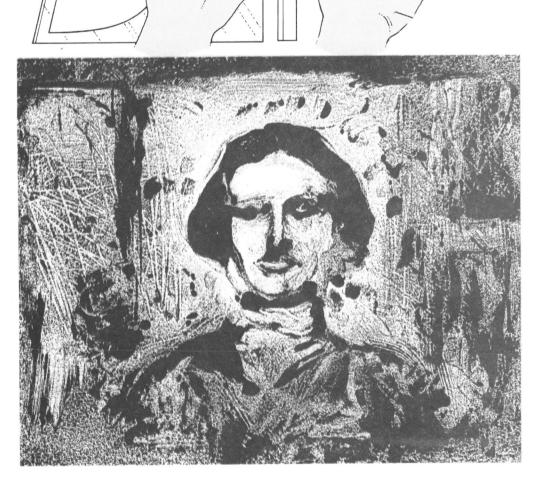

REPRODUCING DRAWINGS

Any drawing you make can be reproduced. The number of copies or prints you require will largely dictate the process you choose, which will, in turn, determine the medium you draw with. The quality of the printing can differ greatly. Line reproduction, which can be done by all the methods listed opposite, will cope with any solid line. Tonal reproduction is achieved photographically and is a more complex procedure. The pencil drawing reproduced below in line, tone and colour shows the different effects produced by these processes.

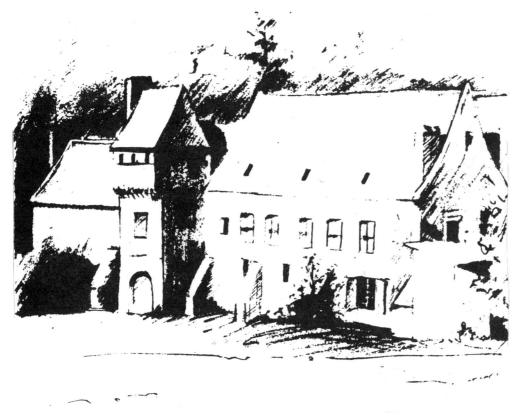

Line A solid, well defined mark on white paper will print by line reproduction. Tones can be reproduced only if they are hatched or stippled. An ink line is ideal, but faint pencil lines disappear and even darker lines break up, although this can look effective. Only dark marks show, so mistakes on the original can be whited out.

Tone The tones of a pencil drawing are broken up and printed as a series of dots, which vary in size depending on the density of tone. A solid line will be broken up also into dots and be less well-defined. This is done photographically.

Colour Any black drawing on white paper can be printed with coloured ink onto coloured paper if you wish. Black on white produces the strongest images, however, and any other colour you use will reduce the impact of the drawing. The colour affects the mood.

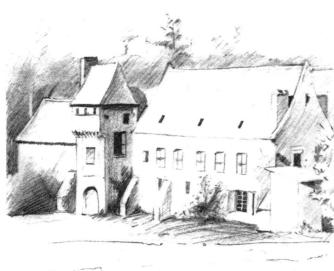

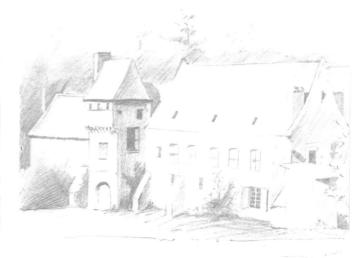

Methods of printing Photocopying This is the fastest and cheapest way of reproducing small quantities of a drawing most printers and public libraries have machines. It is suitable for reproducing black line work but will also cope with tone reasonably well. The print is normally the same size as the original, although some copiers will reduce the image by set proportions. Most machines only work with special paper, but some print onto a paper of vour choice. Colour photocopiers are available. **Dyeline printing The** original drawing must be

made on tracing paper to

reproduce as a black and

white same-size copy. For

background darkens as the contrast of the drawing decreases. A good way of producing posters as it will make enlarged prints.

best results, producing a crisp line on a white background, ink should be

used because the

Photographic printing
Drawings can be
reproduced as line, tone or
colour photographs. The
original can be enlarged or
reduced. The price
increases according to size
and is too expensive if you
need large numbers of
prints. Glossy or matt
paper can be used.

Block and plate printing A printer can convert a line or tone drawing into a block or plate which transfers ink to paper. The main expense is in making the plate and therefore the more you have printed the cheaper it becomes. Almost any card stock or paper is available, but it is worth discussing this and other aspects of your proposed project with the printer before embarking on the finished drawing as it may affect your technique.

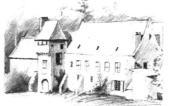

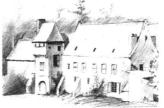

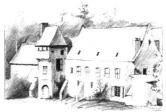

Preparing a drawing for reproduction

Having chosen your subject and medium, discuss the project with your printer, telling him what you can afford, how many copies you need and the kind of paper you want to use. Consider, too, the size print you want — reducing will tighten the image but may mean loss of detail, enlarging will exaggerate the quality of the line and may cause distortion.

If your drawing is well presented there will be less chance of it being damaged. Attach the paper to a sheet of stiff cardboard, taped at the top with masking tape, so that it can be detached readily.

Tape a sheet of tracing paper over the drawing. This will protect it and will enable you to write instructions to the printer over the drawing, such as where marks should be masked out. Finally, cover with thick paper.

REFERENCE

Drawing is a very personal art, a spontaneous and direct visual realization of one's response to an object or emotion. Therefore the more sympathetic the materials used, the more personal the image becomes. Having chosen your materials, their preparation is then part of the act of drawing. For instance, to tint your paper or, to take it one step further, to make your own paper, gives you a surface which you have determined.

The traditional method of quill-cutting is described here, a method easily adapted to cutting any hollow twig or cane. Homemade pastels have advantages over bought ones: they are brighter, and you will have exactly the colours you want, or the ones you cannot buy.

There are also practical hints on fixing drawings, making sketchbooks, a portfolio, mounts and frames, all economical measures as well as being satisfying to do.

Oil pastels on Ingres paper

MAKING DRAWING TOOLS

If you find that you have gone out sketching without a pen, pencil or piece of charcoal try improvising by whittling down a twig and dipping it into ink; even matches will make some kind of mark. Then you could also shave the end of your paintbrush into a sort of pen. Some exciting and unexpected results may come of this potential disaster. A reed pen can be made from a piece of bamboo or other hollow twig in a similar way to the traditional method of cutting a quill.

Cutting a quill

The flight feathers of a turkey, swan, goose or crow can be cut to make a strong, flexible and

1 Strip the barbs off the feather and scrape the barrel to remove the horny skin.

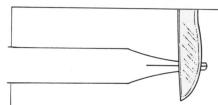

4 Now (or after step 2.) cutting on a hard surface, make a slit at the end of the nib.

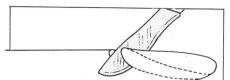

yet delicate pen. To cure the feathers either

hang them in a dry, airy place for about one

year, or cut off the end, soak in water and

2 Find the natural curve and make an oblique cut on the underside with a thin blade.

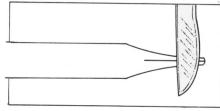

5 Cut off the end to any shape with the blade at an oblique angle. Trim the end with a vertical cut.

3 Make two more cuts to hollow out the sides (this gives the quill its spring).

6 Bend a $2mm \times 3cm$ strip of thin metal such as tin into a spring. This will act as a reservoir.

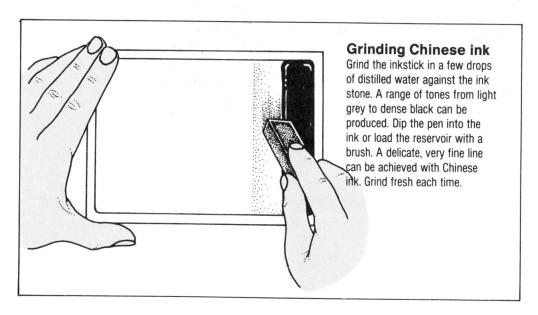

Making soft pastels

Pastels can be made very economically and you will find that, with practice, you will be able to make exactly the colours you want to use. The equipment is fairly basic; you will need a ground glass slab and a muller (or a mortar and pestle, or you can make do with a spatula and a hard surface) and a palette knife. Materials are

pigment, whiting and gum tragacanth.

First you must mix up a binder for the pigment. To make this add 3g gum tragacanth to one litre of cold water. Cover this mixture and allow it to stand overnight in a warm place. Next day divide it into three parts: put one part aside; mix up one part with an equal quantity of

water; mix one part with twice the amount of water. Different pigments require different strengths of binder, for example burnt sienna needs medium strength, raw umber on the other hand needs only a very weak binder. You will find that you very seldom need to use the strongest mixture.

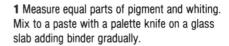

- **2** Grind well with the muller. If the mixture becomes too dry add some water, if it is too wet add some whiting.
- **3** Shape into a stick with the palette knife. Do not make too thin (this is a drawback of many brand-name pastels).
- **4** Transfer onto newsprint. Roll out with the hand or card covered in newsprint to take off some moisture. Allow to dry naturally.

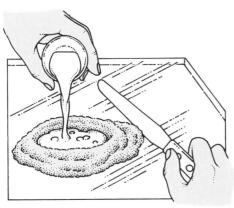

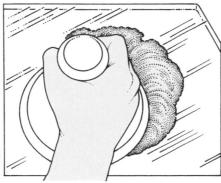

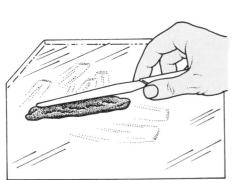

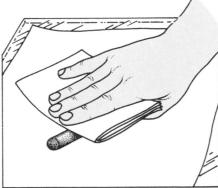

Graded tones can be mixed either by using the raw pigment or the paste. Start with measured amount of half pigment, half whiting (the darkest tone), and a measured amount of white (either whiting or titanium white). Divide the full-tone powder or paste in half, make pastels from one half and add the same quantity of white to the other half. Repeat, replacing the same proportions each time until it becomes as pale as you want it.

PAPER

Making paper

An ingenious method of making paper at home uses old newspaper as its main ingredient. Liquidize some soaked newspaper in warm water for ten to 45 seconds, depending on the coarseness you want. The mould and deckle, the frame on which the paper is formed, can be bought or made at home.

Uncrumpling paper

A crumpled piece of paper or drawing can be ironed flat. Cover a table with some clean cotton, a layer of damp white blotting paper and a dry piece of white paper. Place the crumpled sheet on top and another dry sheet above that. Iron carefully with a moderately hot iron. Remove damp cotton and paper. Iron again through dry paper.

Mould and deckle

1 Make the mould from strips of $50 \times 25\,\text{mm}$ wood, with mitred corners. Reinforce the corners with brass L-shaped braces. Stretch material, eg cheese-cloth, over the frame and staple halfway down the width on the outside, ensuring even tension. Make the deckle from $25 \times 25\,\text{mm}$ strips, to fit on top of the mould exactly.

2 Pour about five loads of pulp from the liquidizer into a basin of warm water. Stir frequently. Fit the deckle over the mould and sweep into the water towards you; level out below the surface; lift out horizontal. Tilt at an angle for five seconds to drain off surplus water.

- **3** Take the deckle off the mould with a swift movement. Wet some absorbent cloths, eg J-cloths, and lay one flat on a board.
- **4** Quickly place the mould on the cloth, press on the back of the mesh to loosen the paper and remove the mould sharply.

- **5** Repeat the process and build up a pile of wet paper sandwiched between cloths, finishing with a cloth. To remove excess water weigh down or clamp between boards for about ten minutes.
- **6** Gently peel off the cloths from one side of the paper and allow to dry for a few hours. Remove the other cloth and dry out completely between blotting paper or separately on a board.

It is worth taking the trouble of stretching paper for a finished drawing to prevent it from cockling. This is essential if you are going to use a watercolour wash, unless you are using a heavy watercolour paper which will withstand the expansion and contraction caused by moisture. It is best to stretch on a hardwood board that will not warp and use brown gummed strip to secure the paper. Paper can be run through water before stretching, and it can also be dampened on both sides with a sponge.

The paper should be left on the board while you are drawing, and cut off with a sharp blade when finished. The board will become heavily scored so try to use paper of the same size to avoid carving up the drawing surface and risking tears and bumps.

1 Immerse one sheet of paper in cold water; to tint paper colour the water with ink or watercolour. Wet paper tears and creases easily so handle with care. Soak for a minute or two.

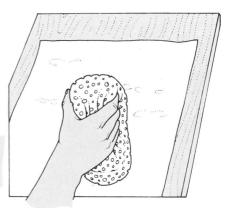

2 Take out of water, allow to drip dry at an angle for a few seconds. Lay on a flat board. Smooth out from centre with a clean sponge or cloth to remove air pockets and excess water.

3 Wet gummed brown paper strip and stick down edges, overlapping paper by about 1 cm. Add an outside layer of strip to mask off board. Masking tape does not stick to wet surfaces.

4 Allow to dry flat naturally. When dry paper can be used on the board. Cut off with sharp blade against a steel ruler. The paper will remain stretched once it has been cut off.

Water colour dabbed on with an old tea bag

Wiping on tints Grind up some broken pastels finely, dab a damp cloth into the colour and wipe over the paper. Apply evenly or create patterns with the colour. Tea and coffee bags can be rubbed onto paper (use already brewed bags), they will give interesting and subtle tints and can be varied tonally.

Tinting

Coloured paper tends to have a uniformity about it that is not very sympathetic. Hand tinting will get over this problem. Paper can be tinted when being stretched by colouring the water with watercolour or ink, by laying a watercolour wash, by wiping colour on with a rag, or, if you are making paper at home, by adding colour to the pulp (see p 110).

Fixing drawings

Pastels, charcoal and soft pencil drawings should be protected or they will smudge. Framing and glazing is the best method, but this is not always practical. Fixing will stabilize the medium and is useful for charcoal and pencil. It does, however, tend to spoil the freshness of pastels, darkening the colours, dulling white highlights, fusing the marks and thus losing crispness. Whenever possible avoid fixing pastels, but with care they can be fixed through the paper from the back. Charcoal can also be treated in this way, but it is not necessary for pencil.

Fixatives can be bought in aerosol cans but it is better to buy it in bottles and spray on with a spray diffuser. Proprietary brands are generally resin based, dissolved in alcohol, but casein can also be used. Skimmed milk has a high casein content and can be sprayed on a drawing in a spray diffuser.

Always fix drawings in a well-ventilated room; the fumes given off by alcohol-based fixatives are highly dangerous if inhaled.

Spraying fixatives

Make sure the diffuser fits together properly and test first to see that the spray is fine and that it does not drip. Lay the drawing flat and spray

a fine mist above it into the air; never spray directly onto the drawing. Repeat two or three times depending on the degree of permanency required. If bubbles appear, heat the paper gently over a radiator.

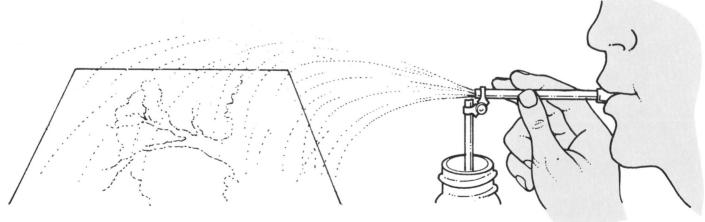

Sketchbooks

Sketchbooks can be bought in a wide variety of size, form (in pads glued or spiral bound or in hardback books) and type of paper. A pad of, for instance, Ingres paper, may have a selection of different colours, but for a variety of different qualities that will suit different subject matters and media you will have to make your own sketchbook.

1 Cut up pieces of paper to the same size and clip them to a piece of hardboard with a bulldog clip. 2 Cut one edge of a wadge of paper quite flush and apply glue thickly to that edge. Both these methods are good temporary arrangements. 3 Your own choice of paper can be commercially spiral bound. Interleave the sheets with tissue paper for pastel or charcoal.

Binding is a more permanent method of making your own sketchbook. Fold about ten sheets of paper with a stout piece on the outside. Stitch in the order shown. Tie a knot in the middle. Paste boards slightly larger than the paper to front and back.

Making a portfolio

Materials needed: board (eg Millboard), paper, knife, metal ruler, bookcloth, white glue, tapes. Cut out the pattern.

Measurements given will take A2 paper. Cover the front of the piece of board with paper, folding a small flap over to the inside edge and glue down thinly all over. Make holes where shown and thread tapes through, sticking down the end on the inside with tape. Glue strips of bookcloth and stick boards together on the front with 3 cm gap between them, leaving an overlap at corners where shown. Stick down with strips on the inside, trimming tape at the edges. Cut corner overlaps on front diagonally and fold in neatly. Cut pieces of paper to cover the inside pieces of board and glue down. Allow the glue to dry out completely before you store your papers and drawings in the portfolio.

MOUNTING AND FRAMING

A mounted, framed and glazed drawing looks impressive; it will also be protected from damp and dust. Window mounting is the best method as it does not interfere with the back of the drawing and keeps the glass away from the paper (essential for pastels and charcoal). A sandwich of glass and hardboard held together with spring clips is a simple and effective method, although not permanent. A drawing can be glued to a card mount or dry mounted, but these methods are not recommended.

Window mounting

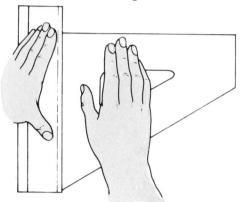

1 Trim the edges of the drawing square, masking off unwanted areas, or mark out in pencil a true rectangle. Decide on the size of the mount (don't make smaller than 6×8 cm). The top and side margins should be equal widths, the bottom margin slightly deeper. Lay the card face up on some heavy cardboard. Cut the overall size of the mount, drawing the knife towards you.

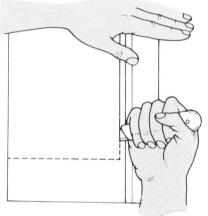

fri ri

2 Mark out the window opening 3mm inwards from the corner of the drawing. If you are right-handed and are cutting on the card face up, cut in the order shown in the diagram.

3 Grip the knife firmly and cut the card with the bevel of the straight edge. Neaten corner 'whiskers' by nicking with a safety-razor blade. Remove card from the centre.

4 Stick a strip of masking tape along the top edge only of the back of the drawing. Turn face up and lay window mount on top.

Cut strong backing card to the same size as the mount.

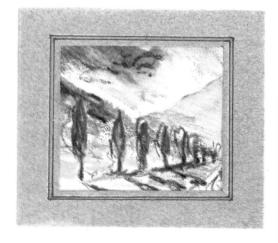

Using a ruling pen

A ruling pen can be used to decorate the mount with fine watercolour or ink lines. Test the thickness of the colour and adjust the pen to produce the required line width. Load colour with a brush to fill one third of the pen (enough to rule whole line.) Rule against the upturned bevelled edge of a steel ruler, with the curved side of the pen outwards, in an even, steady movement.

Decorating the mount

A mount will relate more closely to the drawing if you bring out some of the colours in decorative lines around the bevelled window opening. Draw them with a ruling pen as shown opposite, varying the interval, thickness and colour. 1 simple black or sepia ink lines; 2 watercolour lines, filled in with a dilute watercolour wash applied with a sable brush in the same hue: 3 gold ink lines drawn in with a ruling pen or with a thin sable brush; 4 a step mount, decorated with lines on the outer mount; 5 thin strips of gold gummed paper cut out and stuck down.

Framing a mounted drawing

- 1 Measure the mount and mark out the lengths on the sight edge of the moulding. Cut each piece at an accurate 45° angle in a mitre box with a fine-toothed saw. (Before sawing, make sure that the blade is of sufficient depth to cut to the base of the slots in the mitre box.) Cut the moulding on the outside of the mark. Assemble an L with one short and one long length. Pre-drill holes for panel pins (these are hammered in on the top and bottom of frame, two at each corner). Glue sawn surfaces.
- 2 Clamp both pieces of the L in an inverted V in a vice. Alternatively, clamp one piece and hold the other as shown here. To avoid damaging the moulding, protect it between pieces of cardboard when clamping. Hammer in two panel pins in the previously drilled holes. Next assemble the opposite L. Then glue the two Ls together before pinning the third and fourth corners. Wipe off any excess glue and carefully rub down any slight roughness on the corners with glasspaper or a fine sandpaper.
- 3 It is important at this stage to check that the frame is a true rectangle. When the glue is dry turn the frame face down and fit the glass, the mounted drawing and a backing board on the rebate. Tap in panel pins to secure as shown. Use lengths of gummed strip to seal the join between the frame and the backing board. Fix in screw rings and hang with nylon cord or wire; do not use string it is not strong enough and will break. (With hardwood frames it may be necessary to pre-drill the holes for the rings.)

STORAGE

Materials

Pens Do not leave ink or colour to dry on the nibs of dip pens; remove the nib from the pen holder and scrub well. If you allow the holder to get wet, the wood will warp and the metal fitting will rust. Fountain pens and technical pens should be rinsed out if they are not going to be used for some time. Always be sure to dry metal nibs completely. Pen-cleaning fluids should be used if ink becomes engrained.

Pencils and crayons should be treated with care since the lead is prone to shatter within the barrel if dropped. Stand them, end-up, in a pot or jar or keep them in a box.

Charcoal is brittle and should be stored in tissue paper.

Brushes should always be washed after use with soap or mild detergent. Shake out surplus water, draw sable brushes to a point with your fingers and stand them in a jar with the bristles uppermost. If you are storing brushes for a long time, make sure they are clean and dry and store them in an airtight box with a few mothballs.

Pastels are easily broken or chipped. Store them in a wooden box either in sawdust or on corrugated cardboard. Protect them with cotton wool when travelling as colours will rub off against each other, making them difficult to identify. To clean them put a handful in a jar with sawdust, close the lid and shake gently.

Paper should be stored flat in a cool. dry room, wrapped in clean paper to protect from dust and light. Paper improves with age, so if you find a good quality paper that you particularly like and have good storage facilities, it is worth considering buying in bulk (it is also more economical). Before buying large quantities test for fading. Cut out two squares of paper, leave one exposed to sunlight and cover the other one completely by closing in a book. Compare the two after a couple of weeks. A good quality non-fading paper will withstand this test. Newsprint and other poorer quality (generally woodpulp) papers will deteriorate quickly and should not be stored, take advantage of their short life and low cost to free you from inhibition when you are sketching. It will encourage you to be prolific.

Finished drawings

Take care of all your drawings, even the smallest sketch; they may be useful in the future as reference or even as a basis for a painting. Store them loose in a portfolio (see how to make your own on p113) or in a plan chest; do not store rolled up if possible. Most ink drawings will fade if left in bright light. If you have used a medium that is likely to smudge, the drawing should be fixed or covered with tissue paper, although fixing will destroy the tender chalky quality of pastels. The best protection for soft pastel drawings, which are particularly fragile, is to frame them, taking care that the glass does not touch the surface of the drawing (see p115).

Cleaning drawings

Pen and ink drawings can be cleaned by rubbing gently over the surface of the work with pieces of fresh white bread. The bread will break up and should be removed by brushing lightly with a soft brush.

Weight		Capacity		Size	
28g	1oz	14ml	<u>1</u> fl oz	25mm (2.5cm)	1in
70g	2 <u>1</u> 0Z	28ml	1fl oz	305mm (30.5cm)	12in (1ft)
114g	40Z	284ml	10fl oz (1/2 UK pt)	914mm (91.4cm)	36in (1yd)
227g	8oz	454ml	16fl oz (1 US pt)	1000mm (1m)	39in
454g	1lb	568ml	20fl oz (1 UK pt)	1524mm (1m 52.4cm)	60in (5ft)
1kg	2 <u>1</u> lb	1 litre	13/4 UK pt (2 US pt)		

GLOSSARY

Aerial perspective See Perspective. Brushes A Sable brush is best for applying watercolour washes. If well looked after the initial expense will be repaid by a long life. Other less high quality brushes, such as sabeline, can also be used.

Chiaroscuro (Italian, meaning bright-dark) The play of contrasted light and shade, usually in the depicition of movement.

Complementary colours The colour which contrasts most strongly with a given colour is its complementary, as red is to green, yellow to violet, blue to orange. The retinal after-image that occurs after staring at an intense colour is always its complementary.

Cone of vision Imaginary cone with its apex in the spectator's eye that defines the field of sight.

Conté crayon Crayon of graphite and coloured clay, named after its inventor, it is slightly greasy, hard and rich in texture.

Contour Line indicating the periphery of a volume.

Cross-hatching See Hatching **Eye level** In a perspective system, the height of the horizon on the paper. Anything above eye level slopes down towards the horizon, anything below it rises up to it.

Fixative Invisible coating that prevents fugitive media (such as pastels and charcoal) from coming free of the support.

Foreshortening An object seen from an oblique angle appears not in its true proportions but distorted, or foreshortened: for example, a circle seen from the side is foreshortened into an ellipse.

Gouache Watercolour made opaque by the addition of white pigment. It is fast-drying, denser and more reflective than transparent watercolour. It is also known as 'body colour' and is sometimes sold as 'Designer's colour.'

Gum strip Brown adhesive-backed tape used to attach paper when being stretched on a board.

Half-tone See Tone

Hatching Shading or filling in with lines roughly parallel; more parallel, lines laid across these constitute cross-hatching.

Highlight A point of maximum light on a form often conveyed by the white paper being left blank, or by adding light tones over darker tones.

Ingres paper A soft, grainy, often flecked paper available in a range of subtle tints. Particularly suitable for conté and pastels.

Life drawing Drawing from direct observation of the model (usually nude)

Mass Volume and weight of an object, as opposed to its contour or shape.

Medium (plural, media) The material or technique in which a work of art is executed.

Modelling The description of form by creating the illusion of solidity or volume.

Monochrome Strictly, in one colour, usually, in black and white or brown or grey, without colour.

Negative shape A term applied to the abstract shapes seen in the space between forms. The form may be called a positive shape.

Newsprint Paper on which newspapers are printed, also an economical drawing surface. It is absorbent, of poor quality and has a limited life, but is useful for sketches and studies.

Orthogonals In a perspective system, construction lines that create depth by converging to a vanishing point as opposed to lines parallel to the picture plane.

Pastel Soft (or true) pastels consist of chalk, gum and pigment and adhere only lightly to the paper unless held by a fixative. They have a characteristic soft, chalky texture and subtle colour. Oil pastels have a more limited colour range, they are greasier than soft pastels and adhere better to the paper.

Perspective Conveyance or suggestion of distance in a drawing or painting. Linear perspective involves the use of a grid with a vanishing point on which orthogonals converge. Aerial perspective is the suggestion of space by tone, for instance by lightening the tones as they approach the horizon.

Plane Face or surface, understood as being flat and of two dimensions

(length and breadth but no depth). An object can be drawn as if it consisted of several planes or facets meeting at different angles. Also used to describe areas of a composition, in the same way that foreground, middle- and background are defined. The picture plane is the surface of a painting or drawing.

Plumb line Weighted string that, when held up, will hang down in a correct perpendicular, used to measure a true vertical as an aid to plotting perpendiculars.

Positive shape See Negative shape Primary colours Red, yellow and blue are the primary colours, from which the secondary colours derive by mixing: red with yellow creates orange, yellow with blue creates green, blue with red creates violet. Mixtures of secondary with primary colours create tertiary colours.

Proportion The relation of one unit to a whole or to other units.

Scraperboard Board with a chalky surface that is coated with a layer of ink. An image is scratched through to reveal the layer below, producing a sharp, incised line.

Sepia The inky secretion of a cuttlefish, from which this cool brown coloured ink was originally made.

Sight size Size of an object as it appears to the eye, as opposed to its true size.

Still life Drawing of plants or animals with or without other objects, loosely, any scene without figures that is not landscape.

Stippling Repeated dabbing or dotting with the point of a brush, pen or other medium.

Tone Degree or quality of light or shade, hence dark tones, light tones mid- or half-tones. Colours also may be dark or light and therefore possess a tonal value.

Tooth The degree of surface texture of the paper determined during manufacture.

Vanishing point In perspective, a point on the horizon towards which lines receding into depth converge. Volume The space that a form

occupies. **Wash** Dilution of ink or watercolour applied with a brush or sponge.

INDEX

airbrush, 100	68, 89	finding a pose, 54	Indian ink, 27
anatomy, 50–59	converging lines (orthogonals), 42,	foreshortening, 58	Ingres paper, 8–9, 22, 93
angles: measuring, 42	86–87, 91	groups, 62–63	ink(s), 26–27
perspective and, 86	crayons, 18–21	hands, 52	brush and, 69
planes and, 40, 44	Chinagraph, 18	head, 54	Chinese inkstick, 27, 108
animals, 66–69	coloured pencils, 18	lay figure, 57	Chinese white, 27
drawing fur, 69	combined with other media, 19	life drawing, 56	coloured, 27
sketches and composition, 68		line drawing, 55	diluted ink wash, 26, 70
	Conté, 18, 19, 68, 89		
studying the structure of, 66	water-soluble, 19	male and female shape, 52	filler bottles for stylo-tip pens,
hall naint name OC	wax, 19	moving figures, 61	27 Indian 27
ball-point pens, 26	cross-hatching, 23, 26, 41, 55	portraits, 62	Indian, 27
birds, 67	cubes, 44–45, 91	reclining figure, 58	non-waterproof, 27
block and plate printing, 104	cylinders, 44–45, 87, 91	seated figure, 58	papers, 26
Bristol board, 9	4.4	shape and proportion, 61	printing, 102–103
brush and ink drawing, 69	dividers, 97	simplified planes, 55	removing blots and errors, 27
brushes, sable, 25, 30	proportional, 97	sketches, 52–83	
brush holder, 70	drawing boards, 35	styles of, 55	knives, 70
buildings, drawing, 88–91	outdoor, 70	tonal hatching, 55	craft, 70
architectural details, 90	placing vertically to avoid	fish, 67	scalpel, 70
curves – bridges and arches, 91	distortion, 34-35, 38	fixatives, fixing drawings, 10, 71,	sharpening, 70
free drawing, 89	drawing-board clips, 35	112	X-acto, 70
perspective, 88	drawing by direct transference,	flexible rules, 97	
roof study, 90	42	flowers, drawing, 82	landscape, 72–81
stairs, 91	drawings pins, 35, 70	structure of, 48-49	buildings, 88–91
texture, 90	drawing tools, making, 108-109	foreshortening, 43, 54	composition, 74-75
bulldog clips, 35	dry brush technique, 27	in figure drawing, 58	cone of vision, 42
	dyeline printing, 105	oblique, 58	establishing distance, 72
carbon paper, 98	easels, 70	form, defining, 44	perspective, 86–87
carborundum stone, 70	enlarging and reducing	light on a curved, 44	seascape, 80-81
carpenter's pencil, 14	dividers, 97	simple forms 45	sketching, 74-75
cat, 67	pantograph, 97	use of tone, 44	sky and water, 76-77
chalk, 10	projector, 97	framing a mounted drawing, 115	trees, 78–79
charcoal, 10–13, 72, 78, 89	proportional dividers, 97	French curves, 97	working outside, 70-71
compressed, 10	squaring up, 97		lay-figure, 57
erasing, 35	erasers, 14, 3435, 100	geranium, cross-section of, 48	life drawing, 56
fixing, 10	cleaning, 35	graphite, 14	light, 34
hatching, 41	India, 35	grid	highlight, 44
highlight, 10	putty, 10-11, 23, 35, 45, 71	drawing with, 38-39	main direct, 44
paper suitable for, 10	erasing	enlarging and reducing, 96	on a curved form, 44
powdered, 11	how to erase, 35	natural, 39	reflected, 44
sharpening willow, 11	pastels, 23	groups, 62–63	light box, 98
willow, 10	with a mask, 100	guides, 97	line drawings, 55, 68
children, drawing, 64-65		gum strip, 71	line reproduction, 104
Chinagraph, 14	feet, drawing, 53		line(s), 40
Chinese inkstick, 27, 108	fibre-tip pens, 26, 89, 92	hands, drawing of, 52	converging, 42
grinding, 108	figure drawing, 50–59	hatching, 41, 55, 88, 89	lino-printing roller, 102
Chinese white ink, 27	basic anatomy, 50	cross, 23, 26, 41	
clutch pencils, 12	broken outline, 55	head, drawing of a, 54	mapping pen, 26
cone of vision, 42	children 6465	horse, 67	masking film, 101
cones, 45	composition, 60		masking fluid, 100
Conté pencils/crayons, 18, 19,	feet, 57	India eraser, 35	masking tape, 35, 70, 101
		200	700 day 100 dd dd

masks, 100, 101	surface (HP, Not, rough, wove	converging lines, 86-87, 91	composing from, 92-93
drawing up to a straight edge,	or laid), 8-9	curves, 86	figures, 61
100	textured, 9, 10	drawing a circle, 86	flowers, 82
erasing with, 100	tinting, 112	edges in rounded objects, 87	in the town, 85
hard edge, 101	tracing, 98, 99	establishing distance, 72	landscape, 84, 74-75
ready-made, 101	uncrumpling, 110	eye level, 86	life drawing, 56-57
repeating a pattern, 101	watercolour, 9, 26	foreshortening, 58	sketching bag, 70
soft edge, 101	pastels, 9, 24–27	judging angles by eye, 87	sky and clouds, drawing, 76-77,
spraying over, 100	fixing, 112	one-point, 87	80, 81
varying the edges, 101	grades, 23	two-point, 87	spheres, 44, 45
measuring, 42-43	home-made soft, 109	vanishing point, 87	light on, 44
angles, 43	landscape drawing, 22, 78, 81	Perspex, drawing on, 86	spray diffuser (fixative), 112
using imaginary clock hands, 43	oil, 22	photocopying, 105	stencil brush, 97
with a pencil, 43	papers, 22	photographic printing, 105	stencils, 97
with a plumb line, 43	pencil, 22	planes, 72	still life(s), 35, 46-47
modelling, 44	rubbing out, 23	reducing body to simplified, 55	drawing with a grid, 38–39
monotype print making, 102–103	soft, 23	simple tones and, 40-41, 44	stippling, 26
addditive method, 103	strokes, 23	plumb line, measuring with a, 43	storage, 116
subtractive method, 102	technique, 23	portfolio, making a, 113	
mould and deckle, home-made,	pen and ink drawing, 69	portraits, 62–63	technical pens, 26
111	combining wash with, 27	printing, 102–103	templates, 97
mounting and framing, 114-115	hatching, 41	block and plate, 105	texture, 49, 68, 79, 89, 99
decorating mount, 115	removing blots and errors, 27	dyeline, 105	buildings, 90
using a ruling pen, 114	technique, 26–27	monotype, 105	erasing with a mask, 100
window mounting, 114	various pen marks, 27	photocopying, 105	tonal hatching, 41, 55
Window mounting, 114	pencil(s), 14–15	photographic, 105	tonal reproduction, 104
outdoor drawing, 70–71	Black Beauty, 14	priotographic, 100	tones
drawing in the landscape,	watercolour, 14	quills (goose, etc), 27	making, with pencil, 45
70–71	carpenter's, 14	cutting, 108	planes and, 40–41
establishing distance 72–73	clutch, 14	cutting, 100	use of, 44
materials, 70–71	coloured, 14	reproduction of drawings,	townscapes, 85
setting up, 70–71	Conté, 14	104–105	tracing, 98–99
sotting up, 70 71	fixing, 112	colour, 104	tracing paper, 9, 93, 98, 99
palettes, plastic, 70-71	grades, 14	line, 104	trees, drawing, 78–79
pantograph, 97	hard and soft, 14	methods of printing, 105	11005, drawing, 10-13
paper, 8–9, 110–115	how to hold, 15	preparing a drawing for, 105	vanishing point, 42, 87, 91
attaching to board, 104	making tones with, 15	tonal, 104	viewfinder, 77, 86
cartridge, 9, 10, 26	pastel, 22	rouge paper, 98	violatinadi, 77, 00
fixing drawings, 112	reproducing drawings, 104–105	rubbings, 99	washes
grain or direction, 8	sharpening, 15	ruling pen, 114	combining pen and ink with, 27
handmade, 8	pens, 26–27	RWS paper, 9	diluted ink, 26
home-made, 111	ball-point, 26–27	nwo paper, 5	oil pastel and turpentine, 22
machine-made, 8		Saunders papers, 9	watercolour, 9 30–31, 70, 112
mould-made, 8	dip, 26–27 fibre-tip, 26–27	scale	water, drawing, 77
pastel, 22		figures, 60	watercolour (wash), 9, 30–31, 70
quality, 8	mapping, 26–27	sight size and, 42–43	112
quantity and form, 8	quills, 27	scaipel, 70	
right and wrong side, 8	ruling, 114	• •	combining pen and ink with, 27
sizes and weights, 9	technical, 26	seascapes, 80–81	creating texture with, 31
sketchbooks, 113	perspective, 42–43	sight size, 42	dry wash technique, 31
smooth, 9	analysing cylindrical form, 86	sketchbooks, 113 sketching, sketches, 70, 82–85	wet on wet method, 31
stretching, 111	buildings, 88, 90–91		V sete knife 70
Suctining, 111	constructing a drawing in, 87	animals, 68	X-acto knife, 70